THE MAN WHO LOVED TO DRAW HORSES
James Howe 1780–1836

James Howe was Scotland's first—and is arguably its greatest—animal painter. His drawings and paintings offer a richly detailed, often humorous, view of Scotland in the early nineteenth century—of social custom, of transport, of life in town and country. Horses were not the only animals that Howe drew—he contributed a wide range of illustrations to books on British domestic animals—but clearly he was fascinated by horses. Tired and dishevelled horses, magnificently powerful farm horses, shambling little ponies, brave military horses, elegant hunters, he sketched and painted them all.

A D Cameron, FSA Scot, is a Borderer, born in Selkirk and educated there until he went to Edinburgh University. As a student he played rugby for Edinburgh Borderers (captain 1948–9) and as a history teacher in Hawick he also coached rugby. He became principal teacher of history and latterly an assistant rector in Inverness Royal Academy. A full-time writer since 1973, he is the author of *History of Young Scots, Living in Scotland 1760–1820*, six titles in the 'Exploring History' series for schools, two titles in the 'Then and There' series, three guides to Scottish canals, and *Go Listen to the Crofters* (1968). He is chairman of the Council of the Scottish History Society, now celebrating its centenary. His interests are walking, local history, theatre, agricultural shows, old things and little places.

ISBN 0 08 032466 5

ABERDEEN UNIVERSITY PRESS

THE MAN WHO
LOVED TO DRAW HORSES

THE MAN WHO
LOVED TO DRAW HORSES

JAMES HOWE 1780-1836

A D Cameron

ABERDEEN UNIVERSITY PRESS

First published 1986
Aberdeen University Press
A member of the Pergamon Press Group
© Alexander Cameron 1986

The Publisher gratefully acknowledges subsidy
from the National Museums of Scotland and from the
Scottish Country Life Museums Trust towards the
publication of this volume.

British Library Cataloguing in Publication Data

Cameron, A. D. (Alexander Durand)
 The man who loved to draw horses: James Howe, 1780–1836.
 1. Howe, James—Criticism and interpretation
 I. Title
 741.9411 NC242.H6/

ISBN 0 08 032466 5

Printed in Great Britain
The University Press
Aberdeen

CONTENTS

ACKNOWLEDGEMENTS

I wish to thank very warmly all the people who have given help with this book: the staffs of Edinburgh City Library, the National Library of Scotland, the National Gallery of Scotland, the Scottish United Services Museum, Dundee Art Gallery, and the Mitchell Library in Glasgow; Dr Rosalind Marshall of the Scottish National Portrait Gallery, Francina Irwin of Aberdeen Art Gallery, Robin Rodger of Perth Art Gallery and Hugh Stevenson of Kelvingrove Art Gallery; Meta Viles, assistant librarian of the Royal Scottish Academy and Marion Ramsay, librarian of the Royal Highland and Agricultural Society; Hugh Cheape, Dorothy Kidd and Dr John Shaw of the Royal Museum of Scotland; Dr W H Makey, Edinburgh City Archivist; over twenty curators of art galleries in Scotland and London for information on whether their collections included any works by Howe; John Abott of Barnes, James Bishop of Isle of Whithorn, Albert Brown of North Berwick Museum, J Wotherspoon of Fairlie and W H Yorke of John Swan and Sons, and a great many others who, although not named here, made important contributions about the artist and his work.

Specially to be thanked are Dr A Fenton of the Royal Museum of Scotland for encouragement and advice; Brian Lambie of Biggar Museum Trust for sharing with me his knowledge of Howe's background and paintings, and for reading my text and making valuable suggestions; David Cameron of Milestone Systems, Avonbridge, and Colin MacLean and his colleagues of Aberdeen University Press who skilfully and speedily transformed it into a book.

A D C

INTRODUCTION

It was by accident that I first came across the work of James Howe. In 1975 I was trying to find illustrations of early means of transport in Scotland which had not been previously published and I found a reference in an index in the Edinburgh Room of the City Library to 'the Edinburgh and London Waggon'. Coupled with it was the name of James Howe. This waggon which picked up and delivered goods between towns on the road between Edinburgh and London on a regular, if slow, basis is known well enough to transport historians from the Directories of the early nineteenth century but what it looked like is not. The reference indicated that the illustration was in the Fine Art Department's collection but enquiry there failed to reveal it that day, because it was known to be in store in a dusty attic. When I returned a few days later, however, I found laid out for me not just this drawing but a whole heap of drawings. There were twelve pictures altogether, all bold sketches of horses and men. They were pen and ink drawings which had been quickly done by an artist who clearly understood horses and had a good eye for the lines of a horse, and who also had a sense of humour which the horses at times seemed to share.

All the drawings were on the same kind of paper and all about the same size—approximately 10 × 15 inches; nearly all had a signature, 'How' or 'Howe', somewhere—on a milestone in one, and on the shaft of a cart in two others; and two of them being dated '1830' make it reasonable to infer that they were all drawn by an artist called James How or Howe in or around 1830.

The Edinburgh and London Waggon turned out to be a huge covered waggon of the kind people are more inclined to associate with trails across the American west than with the Great North Road. It had four heavy wheels and was pulled by a proud and powerful team of three Clydesdales with decorated collars and plumes on their heads. On one side stood the driver, in a short top-coat and top hat carrying a whip, and on the other a little dog (which keeps turning up in James Howe's drawings) looking up at the leading dappled horse. With this quick sketch the artist provides a picture of one early

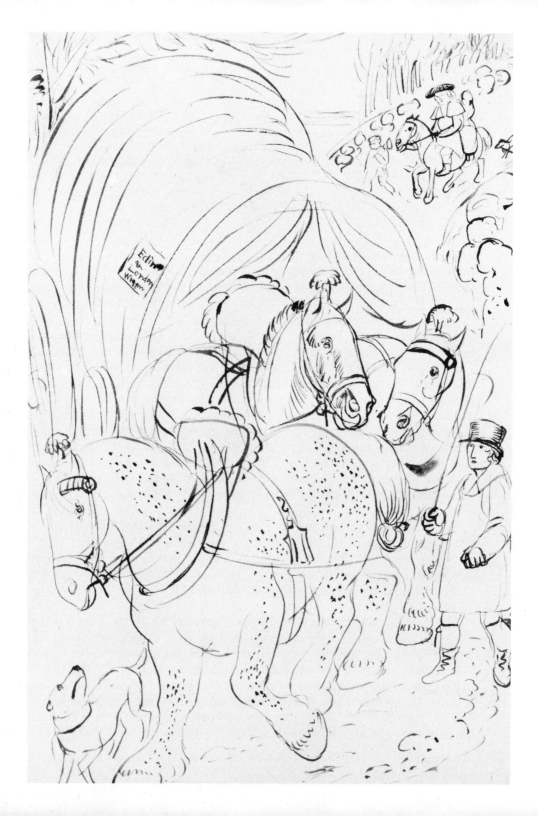

form of transport and to identify what it is he has attached to the waggon's canvas cover the smallest of small notices bearing the words, 'Edin and London Waggon'.

In one of the other drawings a carter approaching the city from the east has stopped at a part-thatched, part-tiled cottage with a notice of toll-bar charges on it and is in the process of handing over the coins to pay his toll. Another sketch, of an old horse which seems to be sagging at the knees, shows its rider holding the hooks with which the horse pulls bathing machines up

[*facing page*] Three Clydesdales pulling the heavy Edinburgh and London Waggon, with their horseman walking beside them, caught Howe's eye in 1830. The Royal Mail Coach could complete the journey fo London in sixty hours by changing horses often: this team, delivering goods from town to town along the Great North Road, took about three weeks. *Reproduced by courtesy of Edinburgh City Libraries.*

[*below*] Old horse employed to pull bathing machines in and out of the water at Portobello beach, 1830 when Portobello was becoming a fashionable seaside resort. *Reproduced by courtesy of Edinburgh City Libraries.*

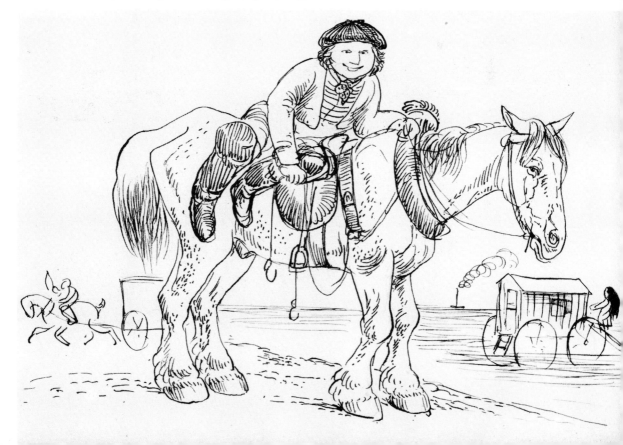

and down the beach according to the state of the tide. The place 'Portobello' is noted on the drawing along with the date '1830'.

This chance find not only provided two illustrations which were exactly the kind I was hoping for but also gave me an unexpected glimpse into my local scene as it must once have been, since I now live within daily sight of Portobello beach. Rough though the drawings may be, they are all of some value because they place details on record which might not otherwise be known, in the same way as photographs have done in later times. They help to illuminate the social life of another age more than a hundred and fifty years ago and also contain some clues to its spirit. To find out how many more of his drawings still existed, and where, and also how much is known about his life has been a constant interest ever since.

Soon it became evident that James Howe has never been numbered among the greatest Scottish artists by art historians, some of whom have made no mention of him at all. One who ignored him was his contemporary and fellow Scot, Allan Cunningham, whose *Lives of British Painters* in the 1830s ran to

Heads of horses drawn by James Howe in 1832 and signed. *Reproduced by courtesy of Royal Highland and Agricultural Society of Scotland.*

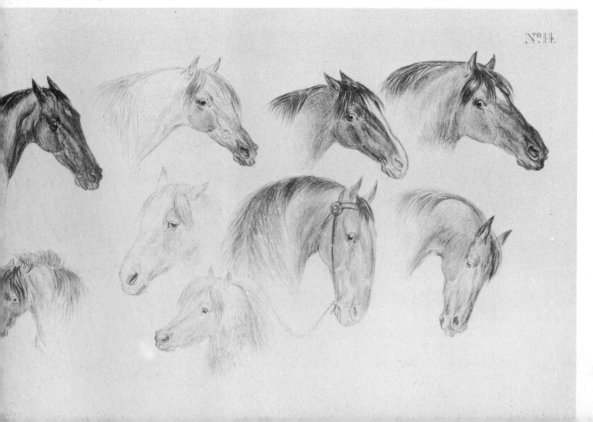

six volumes. But then Cunningham did not mention George Stubbs either, despite Stubbs being recognised today as almost certainly the supreme painter of horses in Britain, and this may be the result of the common belief, of which Basil Taylor complained in *Animal Painting in England* (1955) that animal artists are in some way of a lower order than true artists. W D MacKay, author of *The Scottish School of Painting* (1906) doubtless shared this belief, since he declared that Howe and William Shiels RSA (who painted illustrations for David Low's book *Breeds of Domestic Animals of the British Islands* in 1842) were 'little more than names' and he showed no inclination to find out anything about them.

Other writers, however, who have been impressed by Howe's skill have given fuller accounts of his life and work. From these and other records it is possible to come closer to an artist who had a gift but who always remained very much his own man.

Donkey with dogs.

COUNTRY BOY TO CITY ARTIST

James Howe was born on 31 August 1780 in the village of Skirling in Peeblesshire, where his father, William Howe, had been the parish minister for fifteen years. James was the second of the four children, all boys, of his father's second marriage. In calling the two eldest boys William and James the minister was repeating the names of the children of his first marriage who sadly both died young, within six months of the death of their mother in 1772.

William Blacklaw, schoolmaster, and his pupils, photographed in 1862 in front of the schoolhouse which had been the manse where James Howe grew up. *Reproduced by courtesy of Biggar Museum Trust.*

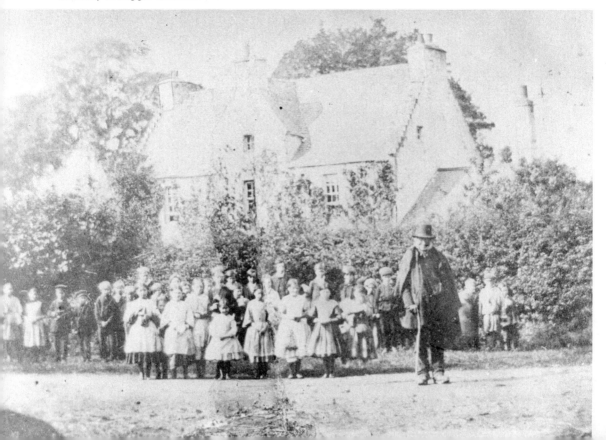

James had a country upbringing in Skirling. This small upland parish, which his father described in 1792 for Sir John Sinclair's *Statistical Account of Scotland*, had a population of only 234. Everyone in the place must have known everyone else but the chances are that as a boy James Howe was more interested in the horses. There were nearly eighty horses in the parish—one for every three people—plough-horses and cart-horses on the farms, carriers' horses and the big house's carriage horses as well as riding horses and ponies. Then there were the horses passing through the village, some pulling loads of lead from the mines at Leadhills and Wanlockhead. The manse where James lived became the school which, reconstructed and extended in 1863, still stands on the edge of the Green where some of the cattle sales were held. The horses were sold in the Horse Market a little further up the hill. The four fairs held at Skirling every year excited him most, in particular the Horse Fair held in

Highland drovers with cattle. Drovers brought cattle from all over the Highlands to the Lowland markets such as Falkirk, Edinburgh and Skirling, and then on to the buyers' farms in England. They preferred the higher drove roads where there were no tolls to pay, and usually more for the beasts to eat. *Reproduced by courtesy of National Galleries of Scotland, Edinburgh.*

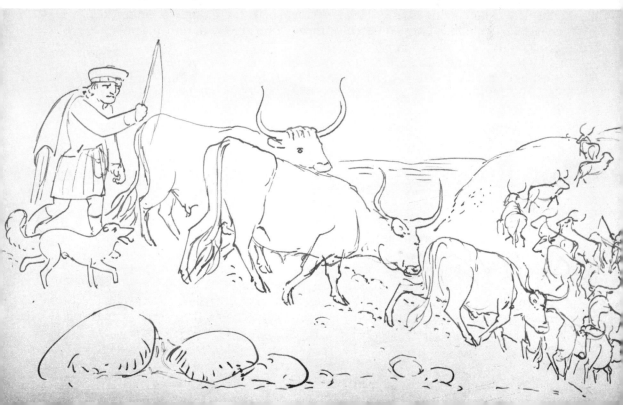

the middle of June which was so big that it set the prices of working horses
for the season in the south of Scotland, and the Old Skirling Fair in September
when great numbers of black cattle and horses were brought in from all
directions and overflowed the middle of the village. Skirling might be a quiet
little place with two modest inns as a rule but on a fair day it was transformed.
William Hunter's description of it was published in 1867, three years after the
fairs were transferred to Biggar:

> The June fair of Skirling was long one of the largest markets in Scotland for
> horses and cattle... Cattle dealers, horse coupers [horse dealers], ballad singers,
> pick-pockets, prick-the-garters [swindling gamesters], hawkers of curry combs
> [for rubbing down horses], recruiting parties with fifes and drums, merchants
> with their stands, and ginger-bread Neds with their baskets were all pursuing
> their respective vocations with intense assiduity and clamour.[1]

The notice of customs dues which the laird, Thomas G Carmichael, issued
for the June fair in 1837 testifies to the great age of the fairs by still expressing
the amounts due in Scots money. Ever since the Union of 1707 the coinage
had become uniform, with one penny sterling taking the place of one shilling
Scots. The main charges were 2 shillings Scots on the sale of every horse and
1 shilling Scots on every cow and, probably in an attempt to discourage
outsiders from coming in and setting up their tents for the sale of liquor, a
charge of 12 shillings Scots on each of them, compared with only 6 shillings
Scots on residents of the parish.

All the noise and the constant movement of animals and people at the fairs
must have lived on in James Howe's mind when he was grown up and living
away from Skirling because he was nearly fifty when he painted the pictures
for which he is most famous, his studies of Skirling Fair. In the village now
it is not difficult to identify buildings, still standing, which appear in these
pictures: his father's church, for instance, dating from 1720 (though recon-
structed since in 1891), the low cottages dated 1816 round the Green, and a
building, once a smiddy, adjacent to the smiddy he painted, which was a busy
place on a fair day because it was right beside the Horse Market.

This part of Peeblesshire was surveyed in 1856 when the fairs were still
happening in Skirling. The resulting O.S. 6 inch map identifies three market
sites: one cattle market on the Green, another on the triangle of open ground
beside Goatfoot Farm, and the horse market between them south of Geldie's
Knowe. Other features important to the Skirling fairs still catch the eye—the
little Skirling Burn running through the Horse Market, handily placed for
watering the horses, and the broad green roads, grazed by sheep now, which
converge on the village. One of them, rising steeply from the corner of the

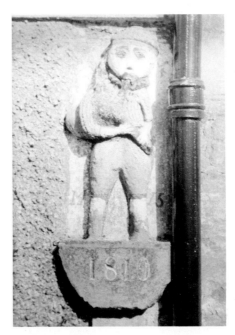

The piper on the wall beside the site of the Cattle Market at Skirling.

Green, was the old road the drovers followed with the cattle they had bought over to Broughton to join the route through Annandale into England. The painted carving of the piper playing his bagpipes may have come from Skirling Castle, but having been in the wall overlooking the Cattle Market since the year 1810, he is a reminder of the kind of colourful characters who used to come to the fairs.

James attended the village school in Skirling when Robert Davidson was schoolmaster. Davidson was well known locally for the quality of his handwriting and people often asked him to write their names in their bibles, which he would do and adorn them with drawings of flowers and animals. It has been suggested that James Howe left school 'still young and incompletely educated' and that this happened when he was only thirteen,[2] but Robert Davidson certainly had a considerable influence on him. James was always making drawings on every piece of paper he could lay hands on. Even his father's sermons were not safe: opening his notes in the pulpit when he was ready to preach, the minister often found they had been decorated with James' latest drawings of animals.

His first known painting, which shows that he was experimenting early with oil paints, is of a boy on a brown pony painted on wood. It never left Skirling, where it hung in the joiner's shop and received far too many coats of varnish over the years. J W Buchan in his *History of Peeblesshire*[3] has suggested that James Proudfoot, later minister of Coulter who wrote the lines in praise of James Howe as an artist on his tombstone in Skirling churchyard, was 'his old schoolmaster' but this cannot be true. James Proudfoot was not even born when James Howe left school and did not become schoolmaster of Skirling until 1817, when Howe was thirty-seven.

Howe's first known oil painting, until recently very dark from repeated coats of varnish in the Skirling joiner's shop where it lay. It is now so clean that the grain of the wood panel on which it is painted shows through. *Reproduced by courtesy of Biggar Museum Trust.*

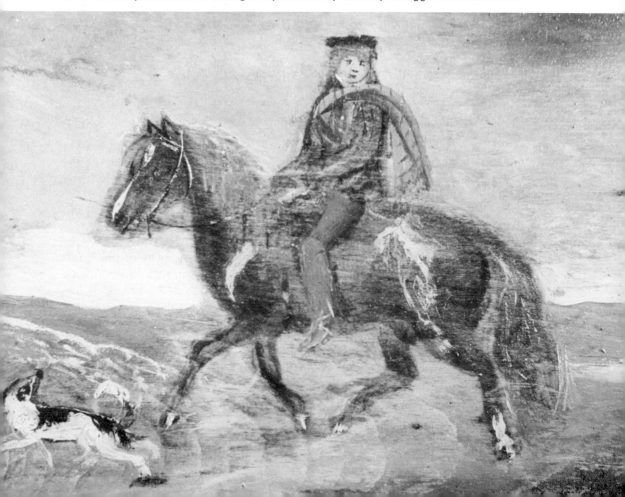

Anderson who, as we have seen, had James Howe leaving school at thirteen relates that he was 'sent to Edinburgh to learn the trade of a house- painter' and J L Caw in *Scottish Painting Past and Present* (1908) also takes a low view of the start the minister gave his son in life. He states 'the best the poor parson could do to advance his son's artistic inclinations was to send him to the Nories [painters and interior decorators] in Edinburgh to learn their trade'.[4] In fact with a stipend of £38.17s.8d, sixteen bolls of barley, seventeen and a half bolls of meal, besides a manse and a glebe of seven acres, William Howe might be among the poorer ministers in Scotland but compared with most of his congregation he was not poor. His eldest son, William, did go to Edinburgh when he was only thirteen to become an apprentice to John Spottiswood, a merchant and ironmonger, so that when James went to Edinburgh in April 1795 his elder brother was already living in the city. James was fourteen and a half, not thirteen, when he left the village but the reason why he was kept at school longer than William is not known; and when he became an apprentice, it was to Walter Smiton (or Smeaton), a painter, for seven years, and not to the Nories.[5] The firm of Smiton and Chancellor were coach painters in the Canongate. Since Smiton, who was a Bailie of the Canongate,[6] took on six apprentices in the twelve years from 1785 to 1796, his must have been quite a big firm, in which seven-year instead of six-year apprenticeships were becoming the rule. Alex Cumin, a teacher's son who was taken on the year before James, and John Houston, a tailor's son who came eighteen months after him, were also serving seven-year apprenticeships. Compared with this the Nories (an old-established firm, respected and often employed by the architects, William and Robert Adam, to paint classical scenes,[7] depicting ruins, streams and waterfalls, as well as the more routine room decoration) appear to have taken on only two apprentices between 1764 and 1800.[8] One of them, Jacob More, went on to paint in Italy and become a well known landscape painter. It is possible that James Howe moved from Smiton's firm to the Nories some time before his apprenticeship was complete, since the name of his master Walter Smiton disappears from the Post Office Directories in 1797 and up to 1803 only Mrs Smiton's name is recorded at their home at the head of New Street, Canongate. Chancellor, Smiton's partner, appears to have died about the same time and as other accounts, going back to the appreciation of Howe in the *Caledonian Mercury* in 1836,[9] connect James Howe with the Nories, it is likely that he worked for them, if not as an apprentice, then as a journeyman later on.

One of the humbler jobs he did as a young man was to whitewash the inside of the Old Tolbooth which was still being used as a prison. Lord Cockburn, the distinguished judge and writer, condemned the place, calling it 'a most

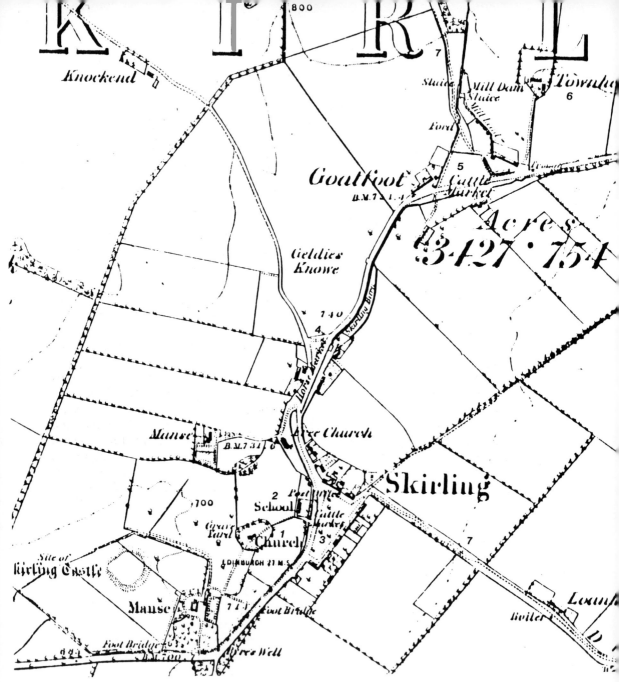

Map of Skirling in 1856 showing (1) church where James's father was minister; (2) school which used to be their manse; (3) Cattle Market on the Green; (4) Horse Market (5) second Cattle Market, where Howe's Brae is now (6) Townhead Farm (now Galalaw) where James Howe died; (7) drove roads north and south of Skirling. *Reproduced by courtesy of National Library of Scotland.*

atrocious jail, the very breath of which almost struck down any stranger who entered its dismal door'.[10] This kind of painting probably did nothing to improve James Howe's skill as an artist but it probably did improve his ability to cover a large area in a very short time.

A break-through came when a Mr Marshall (probably Peter Marshall, painter, 23 North Bridge, whose son William also became an artist)[11] gave him part-time work of a very different kind. Marshall was a pioneer in Edinburgh in providing panoramas of foreign cities or great events as a form of entertainment for the paying public. These exhibitions, a first step towards motion pictures, became very popular. Marshall was making a lot of money. When James Howe did some work for him painting a panorama, Marshall paid him five shillings an hour—more than a house painter could normally earn in a day. That experience encouraged James to believe that he had enough skill to make his living as an artist. His name, occupation and address appear in the Edinburgh Postal Directory for the first time in 1805 when he was twenty-five. The entry reads 'James Howe, portrait painter, 3 Catherine Street.'

He has been criticised for doing this after training as a house-painter 'with little or no art training,' but Alexander Runciman and Jacob More both succeeded after being apprentice house-painters with the Nories. When James Howe arrived in Edinburgh in 1795, the only art training available was at the Trustees' Academy, run by the Board of Trustees for Manufactures, where the course, intended to teach design to craftsmen such as carvers, engravers and calico printers, was probably too restrictive for his peculiar talent. His problem in 1805 was whether what he had to give was what the public wanted.

PORTRAIT PAINTER IN EDINBURGH

> Farmer, at Howe's door, wanting some cattle painted: 'Is this whaur the bruit-penter lives?'
> Howe: 'Aye, come in, come in, are ye wantin' yer picter pentit?'[12]

What most people wanted from an artist then was either a portrait of themselves or their families or else pictures of animals they owned. Howe offered both but it was his natural talent for drawing animals chiefly which attracted the custom of the nobility and gentry. It was easy for them to find where he lived, because a painting of a piebald pony that he put in the window of his studio looked so lifelike that people in the street used to stop and stare to see if it was real. It is less easy for us to discover who the people were in the years that followed who commissioned him to paint portraits which, being family possessions, tend to be away from public view. One notable figure who is known to have been painted by Howe, however, is Sir Walter Scott. Seen standing and glancing sideways, Scott is immediately recognisable with his dog looking up at him and his son and his horse behind him.

In Catherine Street Howe was close to the east end of Princes Street in the New Town. Not that he had cut himself off completely from horses or the countryside because he was beside the Black Bull Inn where there were always coach horses arriving or departing. This was where coaches set off for places in the south, including Carlisle and Dumfries. The *Royal Charlotte* went to London by way of Kelso. The *Royal Telegraph* went to Glasgow. And by going to the stables in the Grassmarket or Candlemaker Row on a Tuesday night when the four Biggar carriers were usually in town, he could talk about horses and learn how the world of Skirling and round about was ticking in his absence.

In 1803 he had painted the yellow banner of the West Linton Whipman Society and four years later he painted on both sides of a piece of blue silk the banner of the Biggar Whipman Society (horsemen) which is now in Biggar Museum. His account for £7.0s.3d. seems to have brought the Biggar Society close to financial crisis, since the minutes record the remedy the Committee agreed in April, 'Every member to pay his proportion of the colours, which is 1s. for every member' but what they received for their money is a gem of

folk art. On it Howe painted the men of the Whipman Society, on horses of every colour including a piebald, riding in procession across a steeply-arched bridge over the Biggar Burn. The men, cheering and waving, are dressed in their best, some with red sashes and all with ribbons decking their hats and their horses. Leading them is a one-toothed musician on horseback playing his fiddle, and over the keystone of the bridge is the Whipman of the year carrying the flag. Through the arch appear scenes symbolising the changes in the country year: ploughing, sowing, harrowing and harvesting, and in the distance the houses of the town.

A very large oil painting of a horse with the title *A Favourite Hunter*, for sale at Sotheby's on 12 March 1986, is known to have been painted by James

The Carrier Stable, a pencil drawing. The four carriers bringing goods from Biggar every week, who stayed overnight with their horses in the Grassmarket or Candlemaker Row in Edinburgh, were Howe's main source of news from Stirling when he lived in Edinburgh. *Reproduced by courtesy of Aberdeen Museum and Art Gallery.*

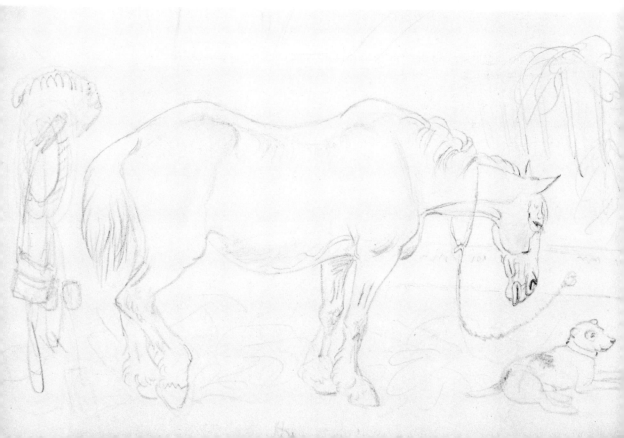

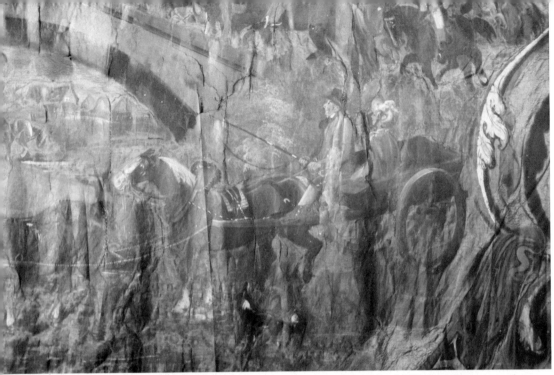

Details from the Biggar Whipman Society banner, painted in 1807 (see front cover).
Reproduced by courtesy of Biggar Museum Trust.
a) Well-dressed owners watching the procession while their own horses have a drink in
 the stream
b) The Whipman carrying the flag, with his followers in close support

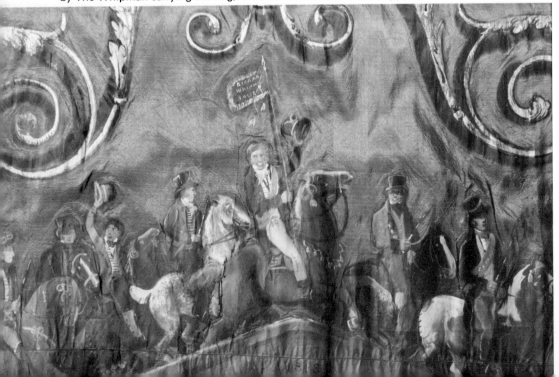

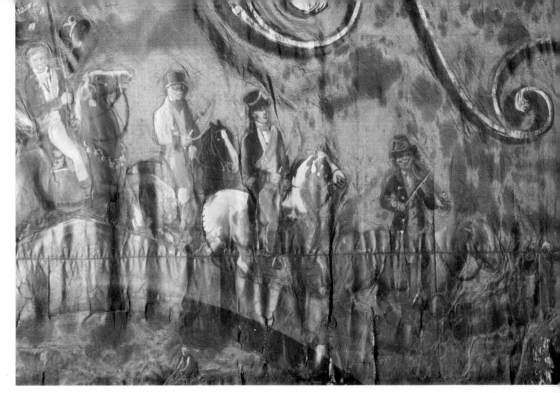

c) Fiddler on a pony leading the procession

d) The farming year – ploughing, broadcasting seed, harrowing, and harvesting the crops.

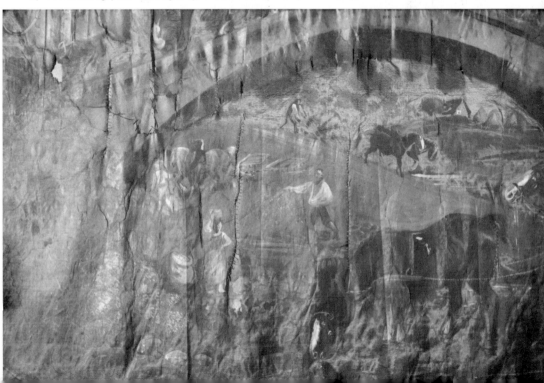

Howe in 1806. Soon afterwards he gained the patronage of David Steuart Erskine, Earl of Buchan, who had founded the Society of Antiquaries of Scotland in the year James Howe was born. Captivated by Sinclair's four volume *Code of Health and Longevity* which came out in 1807, Buchan commissioned Howe to paint portraits of centenarians in the belief that what they looked like was worth recording for posterity. Three of these portraits, of William Sybson aged 106, Mortar Willie also 106, and Elizabeth Ellis who was 103, were sold by auction in 1859.[13]

Buchan, having himself trained in drawing and engraving at the Foulis Academy in Glasgow, advised Howe to seek his fortune in London as an animal painter. Buchan was in the habit of writing to the King on many subjects and he armed Howe with letters of introduction to members of the Royal Household to allow him to paint horses in George III's stables. Howe went to London in 1806, which was incidentally the year when George Stubbs died. His purpose in going was not to win some royal appointment as a painter, as some have implied, but in the hope that if the King would accept one of his paintings, commissions from others would surely flow in. He painted a life-size picture of Adonis, the King's cream charger and also the Queen's favourite spaniel Fanny. The story usually told is that eye trouble prevented George III from looking at pictures at the time but it may be truer to say that the shoes of George Stubbs were not easy to fill. Having failed to win royal favour, Howe advertised the painting to be sold in London by a piano maker in Tottenham Court Road and returned home in 1807.[14]

His trip to London did not in fact do his reputation in Scotland any harm. Although he was not one of the original twelve artists who founded the Society of Artists on 1 April 1808, he gave them support. They arranged the first public exhibition of paintings by living artists ever to be held in Scotland. It took place in the Lyceum in Nicolson Street, which belonged to Charles Henry Core, a china merchant, opening in June and going on till October. The Earl of Buchan was excited by the prospect of annual exhibitions by living artists and, writing to a friend in London, he commented:

> The fine arts begin to flourish in Scotland and I take some degree of pride at having been among the first to promote them... We have [David] Wilkie at the head of his department, even in England and [George] Sanders in his [painting miniatures]; we have in James Howe, who was sent by me to paint the King's

[*facing page*] Portrait of Major George Cuninghame, who was in the Rohilla Horse, Bengal Army in the service of the East India Company. Example of Howe's work as a professional portrait painter. The painting, exhibited in Edinburgh in 1821, is now in the National Army Museum in London.

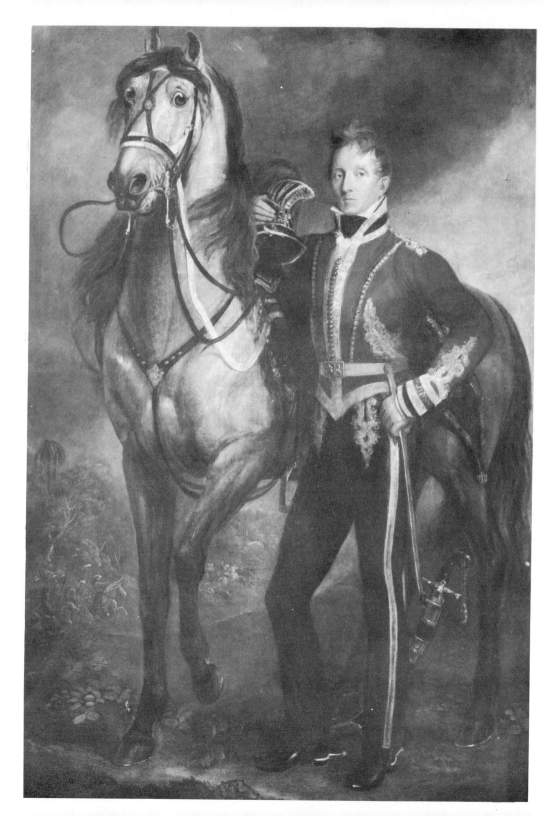

cream coloured charger... a second Stubbs in embryo; and [George] Watson in portrait [later first president of the Royal Scottish Academy] and [Alexander] Carse...[15]

In the first exhibition there were on display two portraits of the Earl of Buchan, in one of which he was more involved than sitters usually are since, although William Home Lizars was the artist, the catalogue states that it was 'painted for, and under his Lordship's direction'. James Howe was also represented twice, with one picture for sale entitled *Baggage Cart*, and a model of his head, the work of M Morrison. When Howe's name was one of eight added to the list of members of the Society of Artists in October 1808, this must have been a mark of his promise as an artist because he was still only twenty-eight.

PICTURES AT THE EXHIBITIONS

Henry Raeburn, the leading portrait painter in Scotland, became a member of the Society of Artists in 1809 and subsequent exhibitions were held in the gallery above his studio at 32 York Place. In the 1811 exhibition James Howe showed five pictures, two of which were of horses, and one a study called *Smithy Door*. More unusual in an art exhibition was a frame containing portraits of different breeds of cattle which Sir John Sinclair had sent him round Scotland to paint. Sinclair was an organiser who got things done, having persuaded the government to establish the Board of Agriculture of Great Britain in 1793, set all the Church of Scotland ministers, James Howe's father among them, to write accounts of their parishes to be published in *The Statistical Account of Scotland* in the 1790s, and followed that up by commissioning reports to be written on the agriculture of every county in Scotland. By choosing Howe to paint these animals which, the catalogue says, 'were painted for, and by order of, the Board of Agriculture', Sinclair and the Board were recognising that he was already the leading animal painter in Scotland. The writer in *Chambers's Edinburgh Journal* in 1839 said he believed that engravings based on these accompanied the article on Agriculture in the *Encyclopaedia Britannica*. This is true of James Cleghorn's article in the Supplement to the 4th and 5th editions which A Constable and Co published in 1815.[16] Six of the studies, half of the total on livestock, are by Howe and their subjects are a Longhorn bull, a Shorthorn bull, a Galloway bull, an Argyllshire bull and a Blackfaced ram, an Ayrshire cow and a Cheviot sheep, and a grey Clydesdale towering over a pony so small that it must be a Shetland. These are the clues to the frame of drawings he had on show in 1811.

Howe's fifth picture, entitled *Interior of a Stable*, which was purchased by the Earl of Buchan, was commented on appreciatively in the catalogue. It was said to be:

> ...in the style of [George] Morland [whose picture *Inside of a Stable* is in the National Gallery in London] and possesses much original genius. The horse is correctly and firmly delineated and the light from the stable door is managed with much judgement. We think Mr Howe is completely in his element when painting cattle and horses; and by persevering in that department, he may attain almost unrivalled eminence.

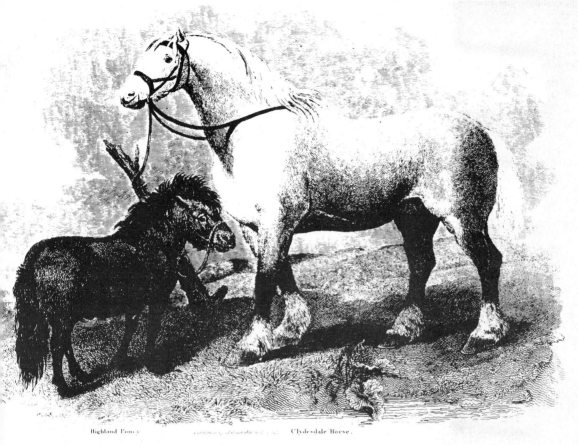

Highland Pony Clydesdale Horse.

Clydesdale and pony drawn by Howe and engraved by Thomas Landseer. In *Encyclopaedia Britannica* 1815. *Reproduced by courtesy of Mitchell Library Glasgow.*

Howe did not take this advice too seriously, because at the next exhibition in 1812 he showed two pictures, one of a colonel on a Spanish horse and the other a portrait of a gamekeeper, Peter Anderson. At this time the artists in the Society, feeling that they ought to be practising life drawing using a male model, and teaching it, arranged to meet in James Howe's house, now at 6 North St David's Street, three evenings a week between seven and nine. The Society split, however, over what should happen to the profits of about £360 a year, which arose from charging visitors to the exhibition one shilling entrance fee or five shillings for the season. The majority favoured sharing the profits and the Society quietly dissolved itself in 1813.

This left living artists without an organisation to display their work but a few of them, including Raeburn and Howe, arranged their own exhibition in 1815. The author of the report in *The Scots Magazine* in May considered that

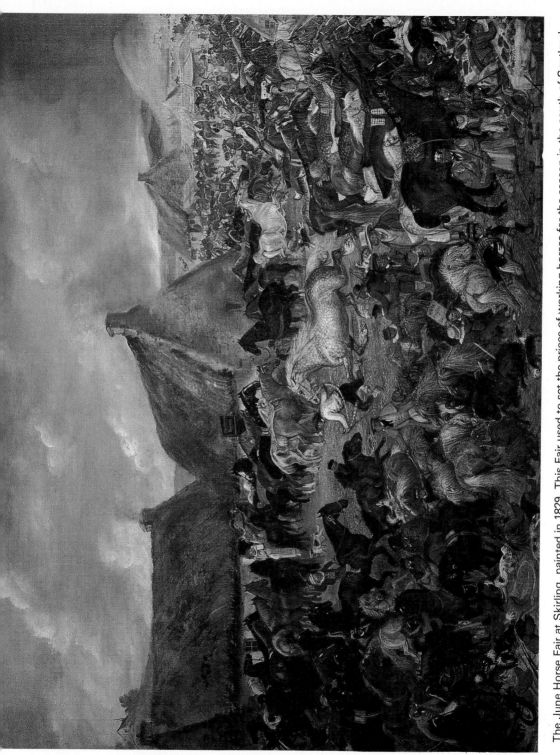

The June Horse Fair at Skirling, painted in 1829. This Fair used to set the prices of working horses for the season in the south of Scotland. Called 'A HOW picture of Skirling' on the placard at the front, this is probably Howe's best known painting. *Private collection. Reproduced by courtesy of National Galleries of Scotland, Edinburgh.*

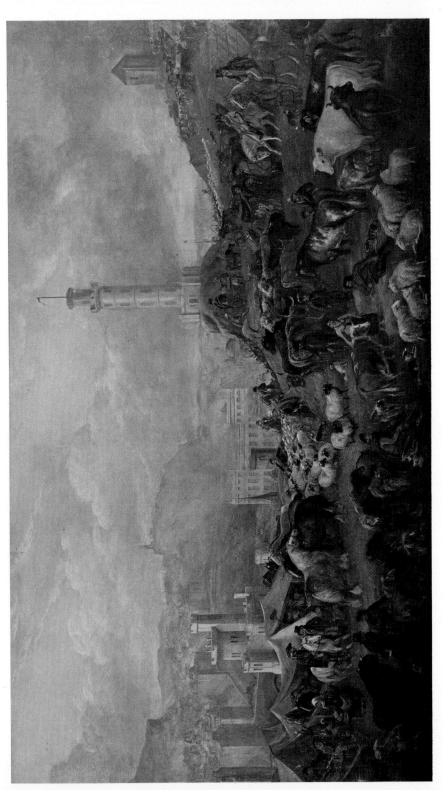

All-Hallow Fair. In this bold panoramic painting, by depicting the All-Hallow Fair on the Calton Hill, Howe brought country and fairground scenes within the setting of Edinburgh city. *Reproduced by courtesy of John Swan & Sons plc Edinburgh.*

Howe's paintings were better than most he had shown in previous exhibitions, and then felt free to criticise them with a somewhat superior air. He praised the composition of *Breaking Up the Camp* and found its colour 'pretty good' but added that it was 'conducted in the same slovenly style as the rest of his works'. In *Cossacks seizing a French Eagle* the length of a horse's neck and the twist to it clearly worried this critic. Without any doubt he believed that artists were required to portray only what was deemed to be correct and were to have no freedom to express what they felt. The third picture, *Hawking at Barochan*, he liked, seeing more good in it than in any of the others. Even so, he found the hawk too large and the landscape lacking in 'aerial perspective', which Ruskin later defined as 'the expression of space by any means'. On learning that a print was to be engraved from the picture, the same critic hoped considerable changes would be made first, if any of his hints 'met the artist's eye or were deemed worthy of his attention'. Whether Howe altered the picture is for the viewer to decide but this is one of his most pleasing compositions, showing three men, Malcolm Fleming of Barochan, 'Falconer to the King', and his two falconers. Malcolm Fleming is on horseback on the left with a hawk on his wrist; John Anderson the falconer is standing in the centre; and William Harvey his assistant is sitting on a log. Anderson and Harvey each have two falcons, and their dogs, spaniels, a pointer, even a French poodle are showing an interest, against a Norie-like vista in which Barochan is prominent, fading away to the right. Prints of falconers are not common: in 1834, late in James Howe's life, Charles Turner, one of the greatest English engravers, made a mezzotint of *Hawking at Barochan*, measuring $19\frac{1}{4} \times 23\frac{1}{8}$ inches, which proved very popular in Victorian times and later. The painting was displayed in the historical section of the Glasgow Exhibition in 1901, lent by Miss Fleming Hamilton. A smaller painting of the same scene, attributed to Howe, sold for £52 at Carberry Tower sale in 1961,[17] compared with £31 in London in June 1922,[18] and the Medici Society reproduced it as a coloured card about 1939.

A new body, the Institution for the Encouragement of the Fine Arts in Scotland, tried to take the place of the Society of Artists. Its members were not practising artists but men of title and property, anyone who could put up a substantial sum to join. At first the Institution felt the right course was to put the old masters which individual members owned on show but in 1821 it returned to the idea of exhibiting works by living artists. Two governors of the Institution were men who took an interest in James Howe, Hon. Henry Maule, later Lord Panmure, who had employed him at Brechin Castle in 1817, and Sir T Gibson Carmichael, Bart., the laird of Skirling.

Now sharing a gallery address at 7 St James Square with Daniel Sommer-

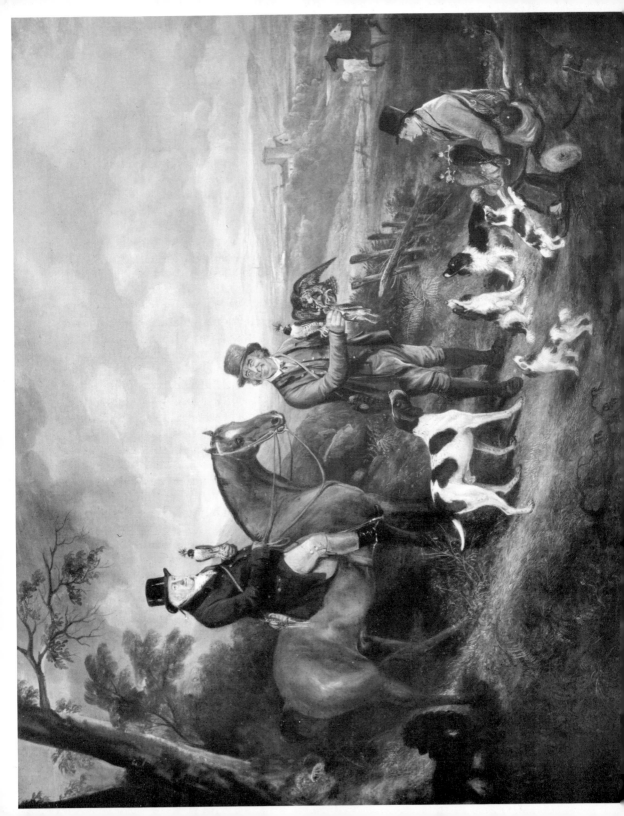

ville, another portrait painter, Howe grasped the opportunity to exhibit again. In the exhibition in Bruce's Gallery, 24 Waterloo Place, in 1821 he showed seven pictures, more than ever before. Two were portraits, one of Major George Cuninghame who was in the Rohilla Horse, Bengal Army. The other, said to have been 'done at one sitting', was of William Crawford, a land surveyor—which sounds like an advertisement of what he could do in a very short time. Of two paintings of cattle, one is a portrait of the *Dunearn Ox*, probably named after the hill outside Burntisland. One of the two paintings of racehorses is his portrait of Outcry (owned by Sir Robert Keith Dick of Prestonfield) at Musselburgh Races in a picture entitled *Preparing to Start*. This is a big well-lit picture, approximately 4 × 6 feet in which the horses look nervous and the jockeys are sizing each other up, as a soldier with bayonet fixed drives two boys behind the rails and armed soldiers in red tunics line the course doing what is a policeman's job today. Prominent in the front is a boy in a brown jacket and red vest, standing by himself with a notice giving the name of Outcry and its owner. At this time Edinburgh paid Musselburgh Town Council to help to arrange the race meetings, put up stands etc. and 1821 incidentally was the year when it was decided there was to be no wine for the jockeys in future. No visitor to the exhibition could have failed to see this picture, since it was No. 1 in the list and the catalogue recommended that they start there, calling it 'The Racehorses above the door'.[19] In the seventh picture, *The Menagerie*, Howe displays an interest in wild or exotic beasts as well as the domesticated kind and probably reveals another field in which he was occasionally commissioned to paint eye-catching animal pictures. A menagerie also appears in the background of a later painting, *The Horse Fair in the Grassmarket*, which is now in the City of Edinburgh Art Gallery.

[*facing page*] *Hawking at Barochan* 1815. Painting of Malcolm Fleming of Barochan, 'Falconer to the King', with his falconers and falcons. Barochan is in the distance on the right. Later became popular as a print. [Private collection]

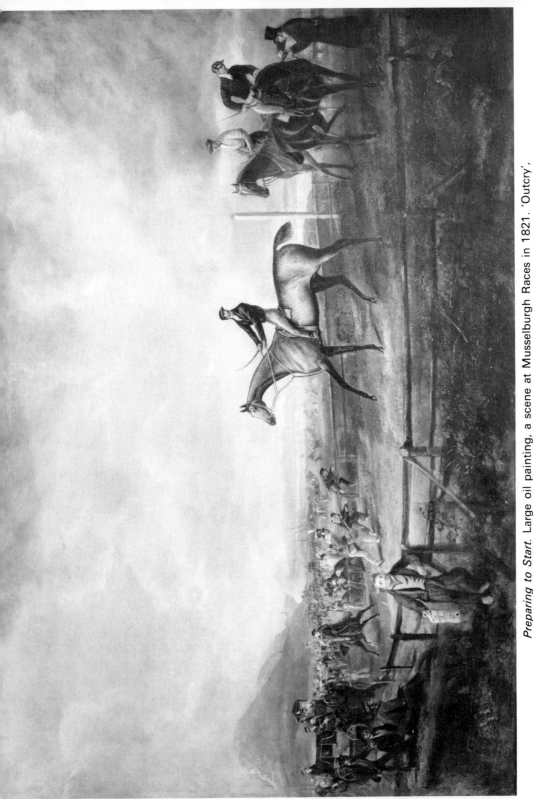

Preparing to Start. Large oil painting, a scene at Musselburgh Races in 1821. 'Outcry', the horse in the centre, was owned by Sir Robert Keith Dick of Prestonfield. The soldiers with fixed bayonets are on duty to keep the course clear. [Private collection]

PAINTER OF PANORAMAS

A panorama of the battle of Waterloo, painted by the French artist, L Dumoulin in 1912, can still be seen on the battlefield today. By entering a round building visitors can experience what it must have been like to have been there on that day, 18 June 1815, in the midst of cavalry charges and hand-to- hand fighting, wounded horses and dying men. The victory the allies won at Waterloo was significant because, in bringing a long war to a close, it marked the downfall of Napoleon as Emperor of France and the end of French dominance in Europe. Such a triumph for a British commander, the Duke of Wellington, with British soldiers playing so large a part, produced in Britain, regardless of the high number of casualties, a mood of national euphoria. Victories at sea had come to be expected in consequence of the British way of waging war: victory on land, being less common, appeared so much more glorious.

Soon the Scottish papers were full of advertisements for publications relating to the battle: a map of the battlefield, for example, for half a crown, a poem, *The Field of Waterloo* by Sir Walter Scott for 5s.6d. (which ran to a second edition by 11 November). Others advertised things to see: for example, as early as 7 July a painter called G Ralph had two pictures on display in 17 Broughton Street, Edinburgh, one called *The Dying Trooper*, which was described as 'emblematic of the devastation caused by war, the warrior represented with the blood pouring from his side'. The advertisement also made it clear that intending viewers were expected to pay.

Within a week of this *The Edinburgh Advertiser* carried a notice that The Edinburgh Packet, David Parker, Master, was loading at the Wet Dock, Leith to sail direct to Ostend in Belgium and that intending passengers should contact the Master or call at the offices of the London and Hull Shipping Company in Leith. We do not know who persuaded James Howe to go (*Chambers's Edinburgh Journal* suggested soon after his death that it was the kind of decision he was not capable of making for himself); or how he went, or with whom. Probably Peter Marshall who had employed him on panoramas in the past had a hand in the decision, and two possible companions were

William Kidd, Howe's young pupil who exhibited in Edinburgh in 1815 and set up in London two years later, and Alexander Carse, another Scottish genre painter, as Howe is known to have been in his company in London after returning from Waterloo. We can not be sure but go he did soon after the battle. The incentive clearly was that this was a time when people would love to see a panorama of this famous victory and would be willing to pay.

This was the most intensely creative period of James Howe's life. He returned home with dozens of sketches of soldiers and horses and guns, and ideas of bodies of men in formation and in disarray, and set to work immediately to create a graphic representation of the battle. 'He completed this in one month,' said *Chambers's Edinburgh Journal* in 1839, 'although he had *four thousand* [square] *feet of canvas to cover.*' In fact it was not so big. The first advertisement for it in the *Caledonian Mercury* and *The Edinburgh Evening Courant* on 26 October emphasised first that he had been there, calling it 'the Accurate View of the ever memorable BATTLE, taken by Mr JAMES HOWE *on the spot*', that it was authoritative, 'every particular circumstance of the battle collected by him from the principal Officers, both British and Foreign, who were in the Battle', and that it was big, 'on a canvas of 1688 [square] feet'. On that date the panorama was announced as an attraction which would be coming soon. James Howe was busy painting it and carpenters were still erecting the large temporary building near Brown's coachworks opposite the east end of York Place where it was to go on display. All the publicity for the show was built on James Howe's name and reputation alone. No other name was mentioned: there was no hint, for instance, of who was putting up the money for the building but it was probably Peter Marshall and Son, because they were known to be the owners after 1815 of a large wooden building near the head of Leith Walk, which was almost certainly this building.

Howe's ability to paint such a large area so quickly owed something no doubt to the practice he had had as a house-painter, but to create in all that space a reconstruction of the battle which would catch the eye and thrill the spirit owed much more to Howe's natural talent for drawing at great speed and the excited energy with which he attacked the work.

Both newspapers welcomed the project and reminded readers of earlier cooperation between Howe and Marshall. They referred approvingly to Howe's earlier work on panoramas having been based on recorded historical facts, and went on to commend the current work for being based on an actual survey of the battlefield. Later advertisements kept the public informed about the progress he was making with what was going to be the first panorama of Waterloo to be displayed in Edinburgh. On 30 October it was said to be 'in a great state of forwardness' and on Friday 10 November at 10 o'clock it was

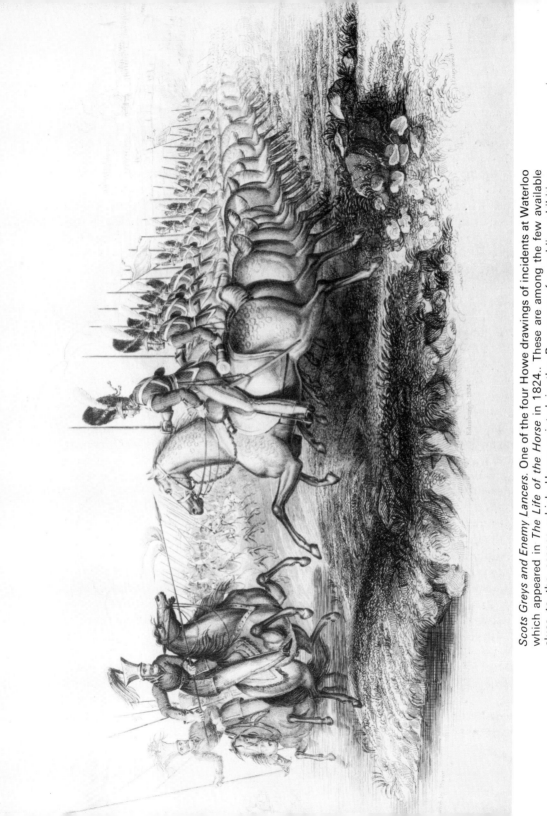

Scots Greys and Enemy Lancers. One of the four Howe drawings of incidents at Waterloo which appeared in *The Life of the Horse* in 1824.. These are among the few available clues to the scenes which Howe painted in the Panoramas for public exhibition. *Reproduced by courtesy of National Library of Scotland.*

open at a cost of two shillings for admission. Described as 'This GRAND PANORAMIC PAINTING' it fixed on the moment in the battle when Napoleon was throwing the last of his forces against Wellington's infantry squares, with the Prussians in the distance advancing to help the British.

Although there was competition from a panorama of St Helena in Princes Street, and from Mrs Siddons and Mr Terry acting in *Macbeth* at the Theatre Royal, Howe's panorama had an enthusiastic welcome. When the excitement subsided a little after three weeks, prices for admission were reduced to one shilling, or five shillings for the season—exactly the same as the Society of Artists had charged for its exhibitions. Winter came early that year: it was so cold in November that people were skating on the Clyde and deep snow made life difficult in Edinburgh for most of December, but an advertisement on St Andrew's Day assured the public that the panorama building was warm, thanks to patent stoves heating the air. Needing few advertisements now, the panorama became part of the Edinburgh scene and the first advertisement in 1816 on 3 Febuary assured the public that the panorama, its size rounded up now to 2000 square feet, continued open from 10 till dusk each day and announced arrangements to allow Waterloo veterans, then returning home in considerable numbers, to see it free of charge.

In spring when Polito's Royal Menagerie was trying to entice the public to the Mound to see his strange beasts—'the horned horse, the zebra, the Royal Bengal tiger, the fiery lynx, the ravenous wolf...', James Howe was painting another panorama. Its subject was the battle of Quatre Bras fought two days before Waterloo, to which Wellington and his officers had rushed after their apparently unruffled departure from the Duchess of Richmond's ball in Brussels. This time Howe's approach was to paint a series of six different scenes—the French position, the Polish lancers attacking the 42nd (the Black Watch), the death of the Duke of Brunswick, the Guards in action, Wellington and his staff, and the distant villages such as Frasnes where Marshal Ney's troops were. When 'this splendid addition', painted on 2000 square feet of canvas was also put on display on Saturday 8 June in the same building, Edinburgh people had the chance to commemorate the first anniversary of the battles by going to see James Howe's two panoramas, covering nearly 4000 square feet of canvas. The exhibition ran, with two extensions, until 3 July; then it was taken down, loaded into waggons and transported to Glasgow.

Most writers, e.g. Anderson, Brydall and Caw, relying too heavily on *Chambers's Edinburgh Journal*, have given Howe credit for one panorama only, the panorama of Waterloo, but the notices in *The Glasgow Herald* and *The Glasgow Courier* on 9 July 1816 which announced that they had opened on Monday 8 July in time for Glasgow Fair confirmed that in Glasgow he

had two panoramas on show:

> TWO GRAND PANORAMIC PAINTINGS of the VICTORIES... on the memorable 16th and 18th of June 1815, at QUATRE BRAS and WATERLOO.

Although there is no evidence of further additions to the panoramas, the total area of canvas on view was again rounded up and was claimed to be 6000 square feet, probably only to impress the public. The place where it was on display was a large wooden building specially put up on the south side of Clyde Street, opposite the City Hospital. The charge for admission was again one shilling, season ticket five shillings and the opening hours 10 a.m. till dusk daily.

Advertisement for the Grand Panorama of Waterloo (not Howe's) on the tenth anniversary of the battle, at the Rotunda, Buchanan Street, Glasgow. From *The Glasgow Looking Glass*, June 1825. *Reproduced by courtesy of Mitchell Library, Glasgow.*

Two oil paintings also owe their origin to Howe's visit to Waterloo. One, called *The Battle of Waterloo* measuring 34 × 54 inches was exhibited at the British Institution in London in 1816, the only occasion when any of his work was shown outside Scotland. This painting having the same title as his first panaroma may be the reason why it has been suggested[20] that the panorama also was exhibited in the British Institution in London in 1816, whereas, as we shall see, it ran in Glasgow until the end of November 1816. The second painting, a small one 18 × 24 inches, *The Scots Greys in Bivouac before the Battle of Waterloo* is now in the Scots Greys' Room of the United Services Museum in Edinburgh Castle. It shows the grey horses unsaddled, gathered together and quietly feeding, some men cooking over campfires, one man drinking soup, another smoking his clay pipe, two of their number on horse-back keeping watch, but most resting in the quiet of the night before the battle: the next day they were to win glory when Sergeant Charles Ewart captured a French colour but they were to lose 102 men and 179 horses killed, and 79 men and 47 horses wounded.[21]

In Glasgow Howe's panoramas were immediately popular. A panorama of the Thames from Windsor to London which was on view elsewhere seems tame in comparison. A portrait of Napoleon at the Assembly Rooms in Ingram Street also cost a shilling to see. *The Glasgow Courier* on 13 July mentioned the choice people had for the Fair:

> Near the Old Bridge, there were an unusual number of exhibitions, such as Polito's Menagerie, the Panorama of Quatre Bras and Waterloo, Tam o' Shanter etc. etc., all of which were crowded with spectators during the whole day. In the evening part of the scaffolding of one of the booths fell, [probably not in Howe's which was a wooden building] by which several people were severely hurt, one woman, we learn, had a leg, and a girl an arm broken.

People kept coming to see Howe's exhibition, day after day, week after week, until on 16 November closure in a fortnight was at last announced along with the concession that tradespeople and children could come and see it for sixpence. It had run for nearly five months and if the figure of £30 usually quoted[22] as the takings on an average day can be relied on, the panoramas were being seen by about six hundred people every day. With his share, half the takings, flowing in to him every day in Glasgow, he was suddenly rich. But he was no businessman and he soon became known as an easy- going high-earner. Drink tempted him and he succumbed, while others who were already addicted found him an easy touch. The restraining hand of the manse had fallen from his shoulder years before, as his father had died when James Howe was only sixteen. When he returned to Edinburgh in 1817, all his money was gone, his health was shattered and his panoramas were never shown again.

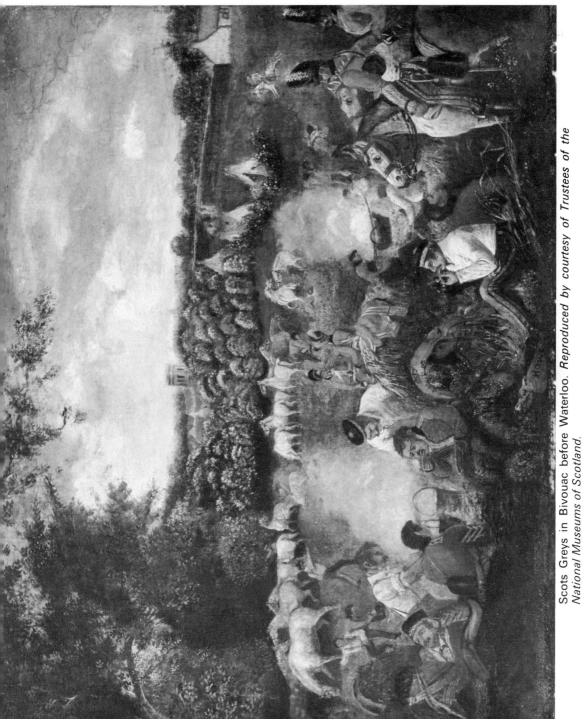

Scots Greys in Bivouac before Waterloo. *Reproduced by courtesy of Trustees of the National Museums of Scotland.*

This was unfortunate, because he missed out on exciting new developments in both cities. In Edinburgh on 10 December 1818 Peter Marshall received permission to erect a wooden building on the north-east corner of the Earthen Mound, close to Princes Street, to show panoramas. The building, which was round with a pointed roof like a haystack and an entrance between classical pillars, was called the *Rotunda*. Instead of using Howe's panoramas on the fifth anniversary of the battles in 1820 Marshall put on 'a Historical Peristrephic [revolving] Panorama' by H A Barker and J Burford of three battles, Ligny, Quatre Bras and Waterloo, which had already been shown successfully in other cities, London, Dublin, Liverpool. There were six separate performances

Men of the Midlothian Yeomanry Cavalry in full uniform: a coloured drawing, 1832. *Reproduced by courtesy of Royal Highland and Agricultural Society of Scotland.*

every day, starting on the hour. At every one, ten episodes of the battles were featured, each episode being accompanied by appropriate music, an army piper playing *The Campbells are Coming* for example, when the Highlanders were charging, and a full military band playing *See the Conquering Hero* for the last grand charge and the appearance in the foreground of the Duke of Wellington. By the use of brilliant lighting, flags and other effects, this panorama on circuit round Britain marked a considerable technical advance on the simple fare James Howe had been able to offer. Each charge looked so real that each succeeding one received an even louder cheer from the audience. Despite higher prices, 2*s.* for the front seats, people came in droves all summer and enjoyed it. Many considered it morally uplifting and *The Edinburgh Evening Courant* recommended it 'for the rising generation in particular'.

At the end of October 1820 Peter Marshall and Son transferred this panorama to Glasgow and brought back to the Rotunda on the Mound *The Bombardment of Algiers* (1816) which had been keeping Glasgow people entertained all summer. This was not unlike the circulation of films from cinema to cinema today and the ownership by Peter Marshall and Son of two rotundas, one in Edinburgh and one in Buchanan Street, Glasgow may be seen as a faint pointer towards the chains of cinemas which were built up this century. A later rotunda was built farther up the Mound in Edinburgh and in 1836, the year of Howe's death, Peter Marshall's son, William, listed his addresses as 100 Princes Street and Rotunda, Mound.[23] Unfortunately not one of the great historical panoramas shown in them exists today.[24] The advances which the ten years after Waterloo witnessed in public entertainment stemmed from a more business-like approach, the provision of purpose-built premises such as the rotundas, the use of more sophisticated effects in presentation, and a touch of showmanship. In Glasgow in 1825, for example, war veterans were offered free admission on the tenth anniversary of the battle and were asked to come wearing their medals. Whether they realised it or not, by being there they had become part of the show.

NEWHAVEN AND NEW DIRECTIONS

Soon after James Howe returned to Edinburgh in 1817 the Hon. Henry Maule gave him the opportunity to escape from poverty and the bottle. Maule invited him to Brechin Castle to paint studies of cattle, described in 1842 as 'very exact representations of the Angus, Galloway and Ayrshire breeds', then hanging in the Farmers' Hall at Brechin[25] (but which now alas can not be traced). Working there quietly for a period of four months helped to restore his health and also his ability to earn since, it is said, he returned to Edinburgh with several hundred pounds and opened a bank account for the first time in his life.[26] His only surviving work that year is a little drawing of mounted Dragoons, measuring only $4\frac{1}{2} \times 5\frac{1}{2}$ inches but described by its owner as 'a gem by the celebrated animal painter James Howe'. In 1818, perhaps with Maule's backing, he applied for the post of Drawing Master in the Trustees' Drawing Academy in Picardy Place but he was not successful. He was still in distinguished company as Alexander Nasmyth, William Allan and Alexander Carse were other disappointed candidates.

He seems to have been working busily in 1820, since the number of paintings he exhibited in 1821 (chap 3) is a fairly reliable guide. Some sources state that he went to live in Newhaven towards the end of 1821 in the hope that the sea air would be good for his health but their suggestion that he stayed on there for the rest of his life is contradicted by the evidence in the Post Office Directories. Now calling himself 'portrait, historical and animal painter' he is recorded annually at the same gallery address, 7 St James' Square between 1822 and 1826 and at a house at 18 Canal Street in 1823 and 1824. Opposite the old town markets (where Waverley Station is now) Canal Street was full of all kinds of traders, including four spirit-dealers. Then, except for the St James Square gallery as an accommodation address in 1825 and '26 his name and address disappear from the Edinburgh lists and do not reappear until 1834. From this it looks as if his first stay in Newhaven in 1821 was only temporary and that he did not move there permanently until after 1824.

It was ill-health, probably sparked off by his weakness of will and his liking for drink, which made him decide to live by the sea at Newhaven. Illness

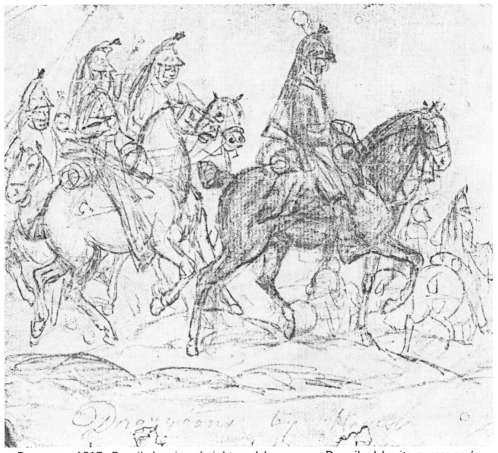

Dragoons, 1817. Pencil drawing, heightened by crayon. Described by its owner as 'a Gem drawn by the Celebrated Animal Painter James Howe'. *Reproduced by courtesy of Biggar Museum Trust.*

seemed to obsess him: if he heard people talking about any disease, he became convinced immediately that that was the one he was suffering from. He seems also to have become absent-minded and unreliable. *Chambers's Edinburgh Journal* tells the story of him walking with friends in Colinton when the sole of his boot tore away and he went to the cobbler to have it mended but failed to return. Searching for him they entered the cobbler's and discovered he had forgotten all about them. The scene was reminiscent of *Tam o'Shanter* with the pair:

> . . . bousing at the nappy
> An' getting fou and unco happy

Lack of money did not stop him drinking either, according to *Chambers's Edinburgh Journal*. James Howe was easily drawn into company and if, with the talk and the drink flowing freely, he found he could not pay, in a minute or two with his pencil he could supply an acceptable drawing instead. The English artist, George Morland (chap 3), was another animal artist who took to drinking heavily, and James Howe's pupil, William Kidd, who pursued his career in London went the same way.

He settled, apparently in comfortable lodgings, in George Street, North Leith, close to the Anchorfield Burn, which is roughly half-way between the Wet Docks at Leith and Newhaven Harbour. Difficult to find and quite far away from the artistic centre in the New Town, he was almost unavailable to paint portraits by appointment any more. Perhaps because he had gone commercial by entering the world of entertainment with his panoramas, perhaps because some artists were jealous of all the money he had made, James Howe ceased to be an artist who belonged to the artistic establishment of Edinburgh. Probably the more generous of his fellow artists now regarded him as talented but wayward. Judging from the portrait of George Watson, the first president of the Royal Scottish Academy, he looks a man unlikely to be tolerant of human weakness, however talented the candidate might be. James Howe played no part in the struggle between the Board of Trustees with their charter in 1823 to build the Royal Institution on the Mound and the practising artists who established a new society of their own, the Royal Scottish Academy in 1826. Whatever the cause—and it may well have been his own lack of ambition after 1826—Howe never became a member of the RSA, whereas among his contemporaries Walter Geikie, the deaf and dumb artist, was elected in 1834 and Howe's pupil, William Kidd who was then in London became an honorary member in 1829.

It would be quite wrong, however, to deduce that the years he spent in Newhaven were unproductive years. Now that he was his own master he could, as his health improved, produce works he wanted to do and carry them through to completion in his own time. One new field of activity was making drawings of animals which would then be turned into engravings and sold to the public. Another new field was inspired by something he saw at the 1821 exhibition,[27] which was the first opportunity he and indeed the public at large had of viewing David Wilkie's picture, *Pitlessie Fair*, which had been painted much earlier in 1804.

Howe and Wilkie were similar in background, both being brought up in

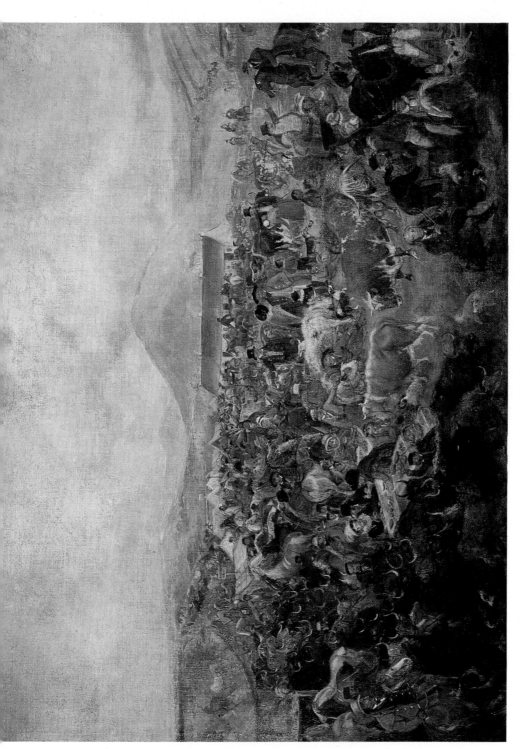

Skirling Fair (Cattle) 1829. In this study of Skirling Fair on the upper Cattle Market below Galalaw, Highland cattle are streaming in along the drove road on the left, while the laird and his family are being welcomed on the right. All the excitement of the Fair—bargaining, courting, fiddling, coaxing animals—goes on noisily between them. Howe is seen in the middle of the picture. *Private collection. Reproduced by courtesy of National Galleries of Scotland, Edinburgh.*

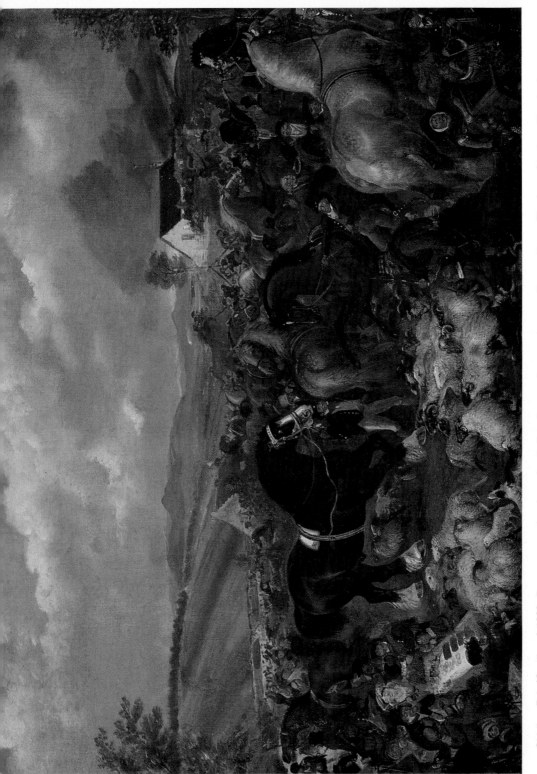

Skirling Fair (Stallions) 1829. Dogs scatter the sheep in all directions and upset the parading stallions. The huge black stallion in the centre and the grey in the lower right, both powerful animals, are apparently under control. The church is on the right, the low cottages on the Green on the left. Also on the left Howe can be seen at his easel. *Private collection. Reproduced by courtesy of National Galleries of Scotland, Edinburgh.*

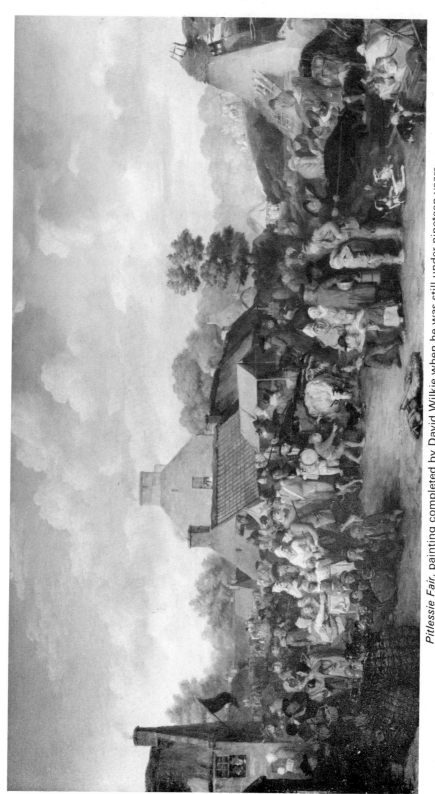

Pitlessie Fair, painting completed by David Wilkie when he was still under nineteen years of age. It was on public display for the first time in 1821. Having seen it, James Howe decided to paint fairs. *Reproduced by courtesy of National Galleries of Scotland, Edinburgh.*

the country, both being the sons of ministers, and both addicted to drawing as children, in Wilkie's case drawing portraits on his slate of pupils at Pitlessie school. Their training was different, however, as Wilkie who was five years younger than Howe trained from 1799 to 1804 at the Trustees' new Drawing Academy in Edinburgh. Their lives were different too: Wilkie departed to London and a highly successful career. Later on they both found the battle of Waterloo a lucrative subject, Howe through his panoramas and Wilkie with his large painting in 1822 *Chelsea Pensioners Reading the Gazette of the Battle of Waterloo*, which the Duke of Wellington had commissioned. Painting this occupied Wilkie for sixteen months and the rate he charged for his time as an established artist seems to have astonished the Duke of Wellington. It is said that on learning the artist's fee was £1260 the Duke paid cash because he did not want his banker to know he had spent so much on a single painting.[28]

At a more modest level Wilkie, before he left home for London, had been promised £25 by the local laird, Charles Kinnear of Kinnear, if he would make him a painting of a country fair. When he finished it in 1804, Wilkie was still under nineteen. It is an astonishingly mature piece of work, skilfully drawn and rich in colour which comes alive with soldiers, people and animals on a fair day in the village he knew best. The story goes that the laird was so pleased with it that he gave Wilkie £40. As soon as James Howe saw it in 1821, he realised that this was the kind of scene he had known since his early days and he began to find subjects for himself to paint in town and country fairs.

PAINTINGS OF FAIRS

Fairs in Edinburgh

A painting by Howe, called *All-Hallow Fair on the Borough Muir* and dated c.1823 is now in Huntly House Museum. In it Edinburgh Castle occupies the middle background with Arthur's Seat a little to the right, which is too close for the scene Howe painted to have been held on the Borough Muir. If the date given is fairly reliable—and there is no reason to doubt it—the All-Hallow Fair, held on 11 and 12 November in 1822 and the Fairs for several years afterwards, took place at Wester Coates close to Whitehouse Toll and that accords with the view Howe painted. Cattle, the main reason for the Fair, fill the foreground, with farmers riding about eyeing groups of beasts, and one farmer on the right bargaining with a drover. Sheep are to be seen rushing past these animals, and away to the right are masses and masses of cattle, their numbers only hinted at by countless small daubs of brown paint. The *Caledonian Mercury* said there were 10,000 black cattle and 3000 sheep in the Fair in 1822 but somewhat fewer the following year.

All sorts of people turned up at the Fair. The *Mercury* reported the presence of many gamblers, the absence of 'prick the garter' men who were now banned, and the arrest of a good many notorious characters during the day. Among the figures James Howe painted in the open air were two veterans of the War pegging along on wooden legs. On the left giving a full view inside the nearest of a long line of tents he showed ordinary people crowded round tables, busy talking and drinking. John Phillip used the same device, and in the same place in his *Scotch Fair* in 1848. Some of Howe's roisterers were soldiers, men of the Scots Greys, one wearing an ordinary hat, and in the midst of them one civilian was sitting with a soldier's helmet on his head, the kind of thing the artist himself might easily have done. Could this be James Howe putting himself in his own picture? His appearance in later paintings of fairs supports the idea that it was.

The painting has quiet areas: an old lady cooking and two children watching, a Highlander sitting alone with only his cluster of ponies beside him, but on the whole it is full of incident. Whereas a photograph can capture a single

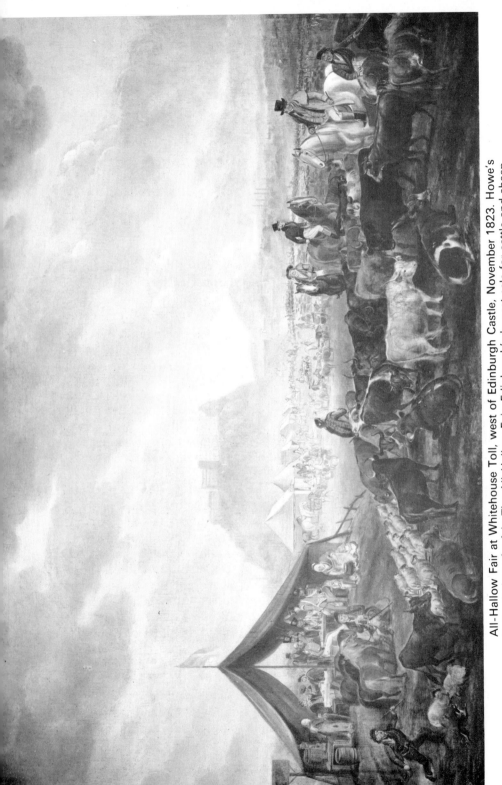

All-Hallow Fair at Whitehouse Toll, west of Edinburgh Castle, November 1823. Howe's first painting of a fair. The All-Hallow Fair, Edinburgh's largest sale for cattle and sheep, was the last big fair in the Scottish season. Howe is in the tent on the left among the soldiers, with one of their helmets on his head. *In the collection of the City of Edinburgh Art Centre.*

moment in time, this painting is a fusion of all the groups and separate incidents the fertile imagination and the deft hand of the artist succeed in bringing together at the same time.

It is interesting that Walter Geikie painted the same Fair, calling it *Hallow Fair at Whitehouse Toll*, and in the same year. Younger than Howe, Geikie was a more faithful follower of Wilkie. In his view of the Fair interest focuses on the people who were there, rather than on the animals. Geikie also took more care: this is proved by the detailed preparatory drawing he made first in pencil, from which he hardly departed at all, save by adding a boy in a barrow beside a heap of baskets in the foreground to catch the eye. If Howe on the other hand ever made a preliminary sketch for a painting, except for his panoramas, it has still to be discovered.

A large picture painted later on a single canvas measuring 4 × 8 feet, the property of John Swan and Sons, is entitled *All-Hallow Fair on the Calton Hill*. Although it is a fact that not once in all the years between 1815 and Howe's death in 1836 was the All-Hallow Fair ever held on the Calton Hill, this is nevertheless an imposing setting in which to depict the Fair. Carefully painted, well lit and full of interesting groups of people and animals, this is probably Howe's most splendid painting. Dominating the centre is the Nelson Monument with the Calton Jail, St Giles' and the Castle on the left and the corner house of the Observatory farther up the hill on the right. The foreground is quiet, the cattle, sheep, Clydesdales and ponies standing undisturbed but a flock of Cheviots coming round the right of the monument sends a bullock careering among tents with a Highlander trying to stop it. There are glimpses of the business side of the Fair, a farmer and a drover bargaining and another farmer listening in, a man clinching a deal for a pony for his son; and the social side, a Highland drover chatting up a girl, a kilted piper sitting playing his bagpipes, people eating and drinking, old friends talking. These are real people and real animals, whatever the licence Howe allowed himself over the location, and *All-Hallow Fair on the Calton Hill* is a valuable social record of the day in Edinburgh's year which brought the country into town.

Skirling Fairs

Other pictures Howe painted show that he kept up his connection with his native village. Richard Robb, the Bailie of Skirling, who was three years younger than Howe, chose to be painted beside his greyhound and his white pony. For the Noble family, masons who took Skirling Craigs farm in 1823 (whose *Diary* was published by Biggar Museum Trust in 1984 and who were tenants of Loanfoot, Skirling without a break till 1976) he painted a group of

their animals, consisting of two horses and a dog. The big and very fine portraits of two of their Clydesdales were treasured by the Stodart family of Covington Hillhead. One is a chestnut with Tinto Hill in the background and the other a particularly strong-looking black horse. It was the proud boast of the Stodarts that they had entertained Robert Burns on his first journey to Edinburgh so well and so long that none of them got to bed at all, and they also quietly admitted that they had 'dried out James Howe many a time.'[29]

In 1829 Howe turned his attention to the fairs at Skirling and produced at least three lively paintings. In one, set at the top of the village by Goatfoot, with Townhead cottages, the farmhouse and Galalaw in the background, cattle predominate, as a great stream of shaggy bodies and long horns flood down the drove road on the left into the centre of the picture where they confront a huge, unaccompanied brown and white bull. On the right is a very different scene, where the laird Sir Thomas Gibson Carmichael on horseback, and Lady Carmichael and their children in a carriage are being welcomed to the fair by Bailie Milne, the factor, and beside him a beggar who is holding out his hat, and hoping. Nearer the front a blind fiddler—who really looks blind—is playing, and he has been identified as a gipsy called Marshall who came from Galloway. Between them all is action: local people parade their beasts, leading them as best they can with halters of straw; a women tests a cow to see what kind of milker it is; stalls and beer tents become busier as more people arrive splashing through the Skirling Burn.

A second painting looking south from Geldie's Knowe features stallions in the Horse Market. Only on the left where better dressed people including the artist are standing and tables are laid ready for them is there any sense of order. Opposite, a woman and a Highlander exchange words after his beast has knocked over her stall. Sheep being scattered by a dog in the front have startled the horses and sent them charging in all directions. In centre stage a great black Clydesdale stallion, thick of leg and huge of hoof, so big that its horseman has to reach up to hold its head, takes pleasure in the exaggerated movements it makes in breaking into a trot across the canvas. 'Too big', 'Yes, out of proportion' were comments two visitors made when this picture was in the *Wilkie Exhibition* in the National Gallery of Scotland in 1985 but the black horse does communicate its sense of power. Hanging beside paintings by other followers of Wilkie, such as William Shiels and John Phillip, this picture looks less finished and less sentimental. It scores by being rumbustious and full of movement, having been painted quickly with zest and a tremendous sense of fun.

The same feeling of excitement pervades the third and probably best known painting, *The Horse Fair at Skirling*. A dapple-grey horse runs to show itself

Site of the Horse Market at Skirling today, the old smiddy just to the right of the War Memorial. Viewed from Geldie's Knowe.

off with its mane and tail flowing, miraculously finding space as children on ponies and big horses charge into its path. Horses for sale, some with their manes plaited and some decorated with ribbons are lined up in rows in front of the smiddy and the inn and all along the opposite side of the burn. All the characters expected at the Fair are there—the sellers; the inn-keeper's wife serving ale; the saddler at his stall; the Highlander and his little ponies; the likely buyers, mostly farmers and dealers; and all the other attractions—the games to play, the laden tables, the beer tents in the distance, all so inter-mingled that they convey the confusion and the noise of that day. As usual there are notices, one to identify a thatched cottage as the smiddy and a placard on a pole displaying the words 'A HOW picture of Skirling'. What is totally unexpected is the appearance near the front of the artist himself. He has taken considerable care to depict his dress accurately: his peaked cap has a check pattern round it, his beige top-coat is open, showing his grey waistcoat

which has fine blue stripes across it, and under his chin is his ample black cravat. He holds his brushes and a palette daubed with blue, red and white paint in his left hand, and is trying to stop a boy clutching the riding crop he has in his right. His garb, quite unlike anyone else's, stamps him immediately as an artist and all the local people knew him as their artist, the one who was born in Skirling.

Another painting, 29 × 44 inches, said to be of Skirling Fair by James Howe, was advertised by Sothebys in 1978 and the price expected was estimated at

Self-portrait. Palette in hand, Howe among the horses at Skirling Fair. A detail from 1829 painting June Horse Fair (see colour plate facing page 20).

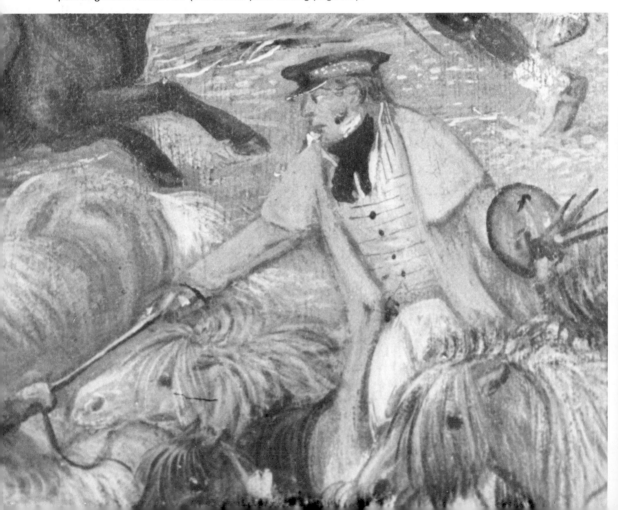

£1200 to £2400. The catalogue referred to the entry about Howe in J L Caw, *Scottish Painting Past and Present* but the accompanying colour illustration was short on horses and gusto, usually features of Howe's work, and the picture was withdrawn.

Other Paintings of Fairs

A writer in *The Scotsman* in 1956[30] mentioned a painting of a Scottish cattle fair by James Howe which he had seen in a house in London and admired but he gave no details. Another Howe painting of a cattle fair, which is now in the United States and can be seen as a black and white photograph in the National Gallery of Scotland may be of somewhere east of Edinburgh. Unusually for Howe, the groups are arranged in the shape of an 'S', winding and disappearing up the slope of a hill, with plenty of spaces in between. It is still full of incident: a group standing back to consider a big grey workhorse, another examining a horse's mouth, a woman milking, a small dog facing up to a huge bull. Overall, this is a calmer, more ordered fair.

Very different is *The Horse Fair in the Grassmarket*, 36 × 45 inches which the Edinburgh City Art Gallery purchased in 1980. The big horse fair took place in mid-November each year at the same time as the All-Hallow Cattle Fair. It is a vigorous, brightly coloured painting of horses in near confusion on the right, with so many horses of every hue lined up in rows on the left that they look like dresses on a rack. Adding to the chaos are a menagerie touting for custom, and men with long ladders who have chosen this time to replace a sign over the White Hart Tavern. Over its arch are the words 'Skirling Carrier every week'—Howe's little joke because Skirling was so small that it had to share the Biggar carriers and this was the Grassmarket in the capital of Scotland. This may have been a late work because it was one of two paintings (the other was of Skirling Fair) which were in Howe's lodgings at the time of his death.[31]

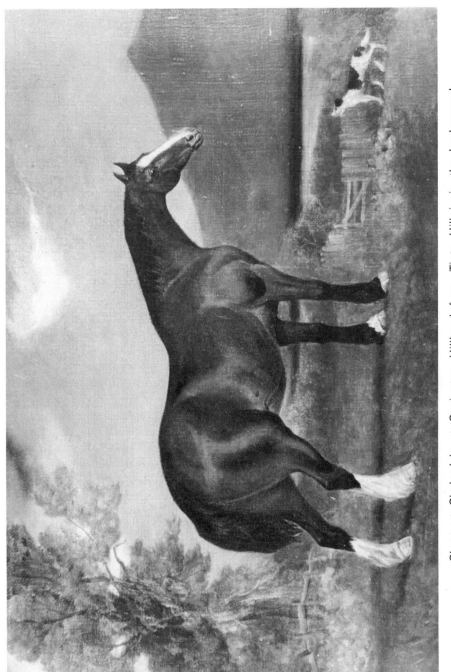

Chestnut Clydesdale at Covington Hillhead farm. Tinto Hill is in the background. *Reproduced by courtesy of Biggar Museum Trust.*

DRAWINGS FOR PUBLICATION

The Life of the Horse

In 1824 fourteen of Howe's drawings were published as engravings under the title *The Life of the Horse*. The engraver of all but three of them was W H Lizars and the printer A Aikman, Junior, of the High Street, Edinburgh. Although the series begins with a young, untrained horse and ends with an old horse, scraggy and lame, being sold for a song in the Grassmarket, each picture is, as would be expected from Howe, different in situation, or use, or breed. One picture is of a riding horse, for example, another of long-legged, lightly-harnessed carriage horses; one of a cart-horse, another of a pair at the plough in East Lothian with their hind; one of a hunting scene, and another of racehorses contesting the finish. The drawings which are of exceptional interest, however, because they are the only clues we have left to the scenes which must have appeared in his panoramas, are four of horses on the battlefield, including one which shows the Scots Greys and lancers on the French side charging each other.

Being much more detailed because they are engravings, these are finer studies of horses than the drawings in Edinburgh City Library. The engraver, W H Lizars, the son of an engraver father, was also a trained painter (chap 2) but concentrated on engraving after taking over the family firm. The engravings could be bought in black and white, or coloured: a coloured print of the old horse being sold in the Grassmarket is in Biggar Museum.

Breeds of Domestic Animals

Howe and Lizars were in the print business again five years later with a pioneering venture entitled *Breeds of Domestic Animals* under the patronage of members of the Highland Society of Scotland. A Mr Wight, an agricultural writer, joined them to provide an introduction and notes about each animal, and the printer was Ballantyne and Co of Edinburgh. The intention was to offer engravings from portraits Howe painted from life, in six parts, each part

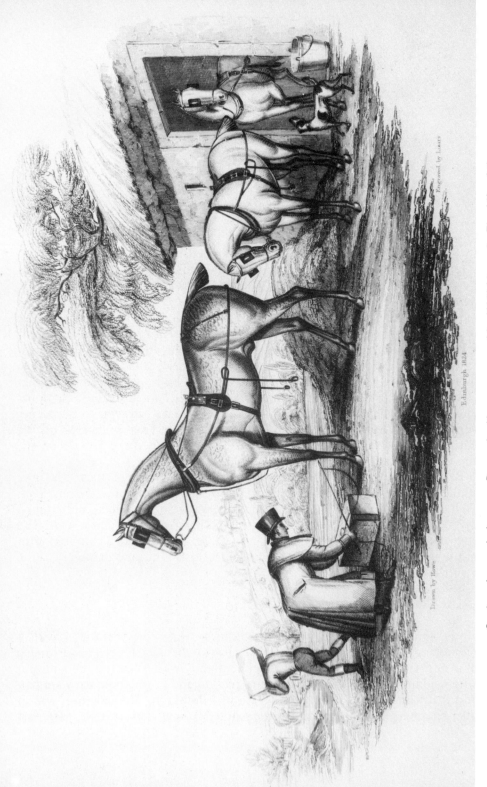

Carriage horses in harness. Drawn by Howe, engraved by W H Lizars, in *The Life of the Horse* 1824. *Reproduced by courtesy of National Library of Scotland.*

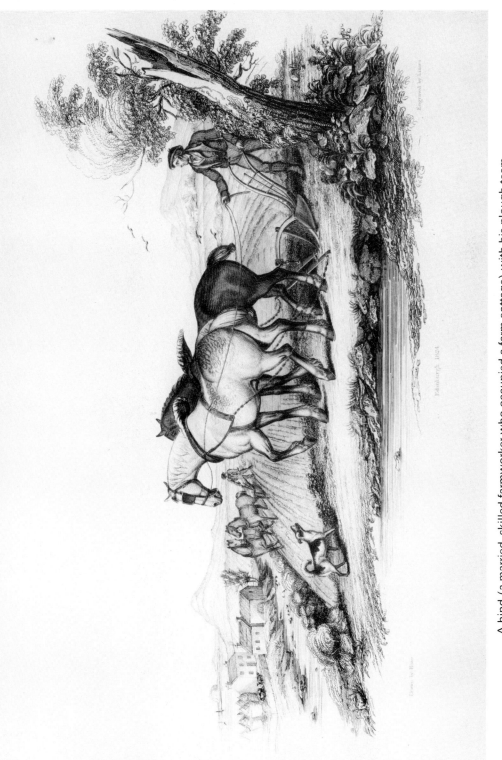

A hind (a married, skilled farmworker who occupied a farm cottage) with his plough team in East Lothian. Engraved by Lizars. *Reproduced by courtesy of National Library of Scotland.*

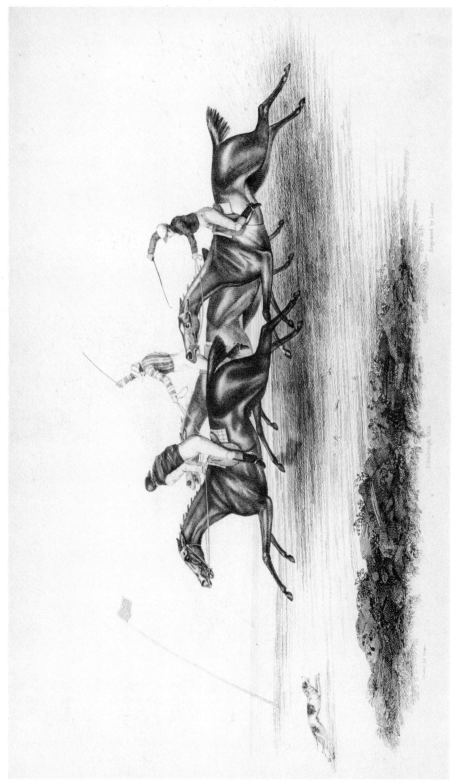

At the Races. Engraved by Lizars. *Reproduced by courtesy of National Library of Scotland.*

comprising four plates, to cost 16 shillings plain or 24 shillings coloured. Although the introduction is dated Edinburgh 1830, the first part is known to have appeared in 1829 because the *Weekly Chronicle* reviewed it with enthusiasm in April and, having copies for likely purchasers to see in August, Howe confirms this in his only known letter:[32]

Meg, a Clydesdale mare, champion at Glasgow Show 1828. From *Breeds of Domestic Animals* 1829–30. *Reproduced by courtesy of National Library of Scotland.*

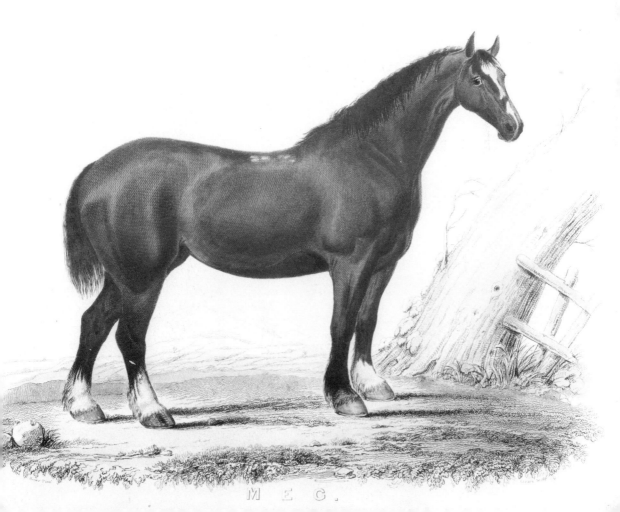

Millburn George St North Leith
Aug 17, 1829

Sir Robert Liston Sir,

Being engaged at present in a National Work on our Domestic Animals, I have
to request the honour of your patronage, the Bearer will hand you the first part
of the work for your inspection...
I have the honour to be Sir Robert
Your obt servt

James Howe

The horses in Part 1 were personalities in their own right—*Duncan* was a
shaggy 33-year old Orkney pony, *Bounty* a 23-year old hunter, winner of the
Caledonian Hunters' Plate at Perth in 1813 and at Musselburgh in 1816,
Canteen an Irish throughbred, and *Meg* a brown 7-year old Clydesdale,
champion at the Glasgow Show in 1828 and descended from *Blaze*, the jet

Ayrshire cows, coloured print in *Breeds of Domestic Animals* 1829. *Reproduced by
courtesy of National Library of Scotland.*

black stallion with white in his hocks and the blaze on his forehead, the proud progenitor of the Clydesdale breed. While prints of these horses were popular for hanging, Part 2 (featuring cattle) and Part 3 (mixed but mainly cattle) aroused less interest. However desirable it might have been thought that the best examples of the breeds of domestic animals ought to be recorded, the project, lacking support, was abandoned.

Portraits of Horses and Prize Cattle

Undeterred by the way support for their *Breeds of Domestic Animals* had dwindled, the same team had a new publication *Portraits of Horses and Prize Cattle* ready in 1832. Confining themselves to horses and cattle only this time, they promised to portray excellence—the best animals to be 'painted by Mr Howe in his best style', with interesting notes by Wight—worthy to stand as a fit companion for *British Domestic Animals*. Each part containing ten

Dairymaid barefoot, luggie on head, out among the cows. *Reproduced by courtesy of Royal Highland and Agricultural Society of Scotland.*

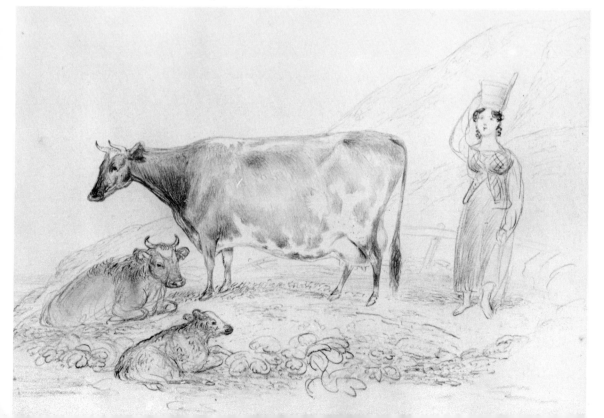

PORTRAITS OF HORSES

OF

DISTINGUISHED MERIT.

PART I.

CONTAINING

TEN DIFFERENT EXAMPLES,

CAREFULLY SELECTED,

WITH

LETTER-PRESS DESCRIPTIONS.

EDINBURGH:
PRINTED BY BALLANTYNE AND COMPANY.

MDCCCXXXII.

TO

THE PRESIDENT, VICE-PRESIDENTS, AND DIRECTORS

OF THE

Highland Society of Scotland.

MY LORDS AND GENTLEMEN,

To you, who represent the Members of a great and Patriotic Institution, the present Work is humbly submitted, as in some degree connected with the objects of your fostering care.

A series of authentic Portraits of our Domesticated Animals would seem to be a desideratum; and a careful selection of the most approved examples, with every aid which professional art and assiduous investigation can bestow, may render this Work not altogether unworthy of the patronage to which it has aspired, and under which pledge your countenance and support is most respectfully solicited, by,

MY LORDS AND GENTLEMEN,

Your most obedient and most devoted Servant,

THE EDITOR.

Title page from *Portraits of Horses*, and Dedication to the Highland Society of Scotland 1832. *Reproduced by courtesy of Royal Highland and Agricultural Society of Scotland.*

pictures was priced at one guinea. The project benefited from having the support of the Royal Highland Society and from the well known people who were willing, and sometimes eager, to have their animals painted for the series. They included the Duke of Buccleuch, the Earl of Hopetoun and Neil Malcolm of Poltalloch for horses, Hugh Watson of Keillor for cattle and C C S Monteith for a bull in harness which used to pull a coal waggon on a railway.

Howe was in his element. He produced some fine studies of outstanding animals which included *Swiss* a racehorse which had changed hands for 2600 guineas; *Foxbury* a charger of 16 hands which carried the tall Earl of Hopetoun when George IV reviewed the Scots Yeomanry Cavalry in 1822; a Highland plough-horse under 14 hands but of exceptional strength; sturdy black cattle; a horned Aberdeenshire ox which was used for ploughing; and an Angus heifer, medallist at Smithfield, which belonged to Hugh Watson of Keillor. Howe's portraits are of great value because they are usually the only record which exists of what these animals looked like in 1832.

Although the number of portraits in the series is much higher, some fifty-

Watering the horse. *Reproduced by courtesy of Royal Highland and Agricultural Society of Scotland.*

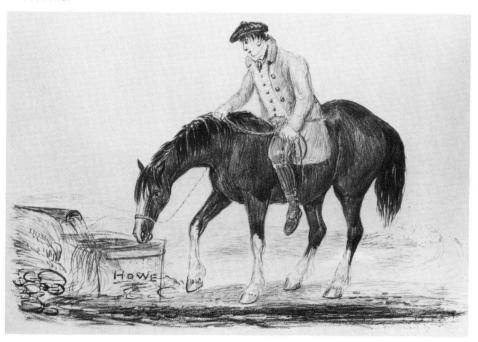

one compared with fourteen in *The Life of the Horse* and fourteen in *Breeds of Domestic Animals*, no one has given Howe the credit he deserves for them. Curiously the writer in *Chambers's Edinburgh Journal* seven years only after they were published does not mention them, nor does Brydall in 1889. Caw in 1908, behaving as if they were part of *Breeds of Domestic Animals*, treats them as a lower form of art and dismisses them as 'completely lacking in pictorial intention and even technical power'. From his comments on other animal artists, it is evident that Caw was no lover of portraits of single animals. Later writers have tended to quote Caw rather than seek out the illustrations and judge for themselves. At the time it probably did not suit David Low, professor of agriculture in Edinburgh University, to give too much credit to this private enterprise record of outstanding animals, because he was putting the case to the Treasury in 1833 for setting up an agricultural museum as an aid to teaching his students. When the Treasury agreed to contribute £300 a year, Low used it to commission William Shiels RSA to portray typical farm animals from life for a series of coloured lithographical prints of cattle, sheep, pigs and horses. These came out in 1840, four years after Howe's death and were the basis for the drawings William Nicholson made to illustrate Low's

Ploughman supping brose. *Reproduced by courtesy of Royal Highland and Agricultural Society of Scotland.*

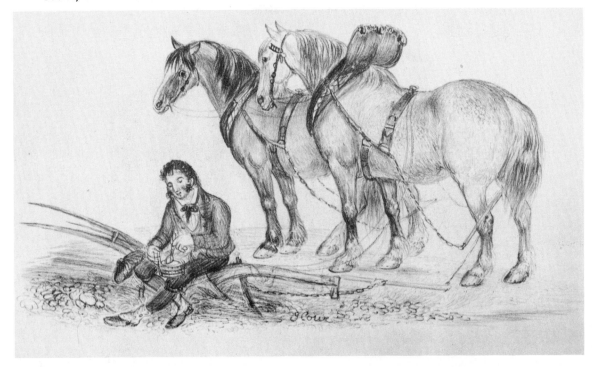

book *Breeds of Domesticated Animals of the British Islands* in 1842.

The volume of *Portraits of Horses and Prize Cattle* which the Royal Highland and Agricultural Society owns contains some welcome surprises. In it are twenty additional drawings, some of which rank among his finest work. Eleven are studies of horses in motion (as opposed to the portraits in which the animals are standing still) and were probably intended to be published as a set. Others are reworkings of spare copies of the portraits, often turned into pleasing compositions. Some are military: beside one cavalry horse, for example, he added another and two men of the Midlothian Yeomanry Cavalry in full regalia. Some are almost studies of horse behaviour: a horse looking on disapprovingly as two others are kicking; and a little pony carrying a Highlander appearing to plead for sympathy because a bigger pony carrying nothing is being led. But most are everyday country scenes—watering horses, a ploughman supping his brose under the gaze of his horses, and a dairymaid carrying a luggie (a wooden pail) on her head beside some cows out in the field. Finally there is a sheet containing nine beautiful drawings of horses' heads and they are all different.

Watson of Keillor's Angus heifer, a prize winner at Smithfield at $4\frac{1}{2}$ years old, with two Blackfaced sheep. From *Portraits of Horses and Prize Cattle*, 1832. *Reproduced by courtesy of Royal Highland and Agricultural Society of Scotland.*

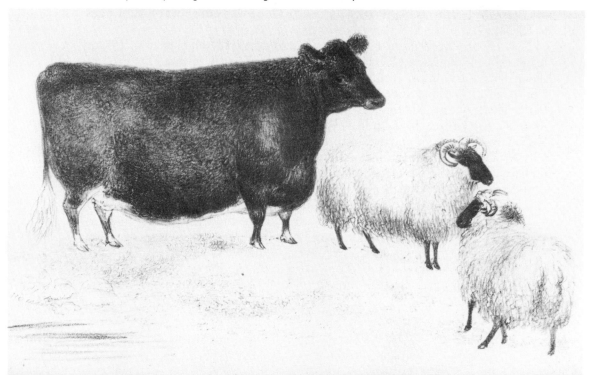

DRAWINGS FOR FUN

Howe may have entered a period of uncertainty and low spirits about 1830 when he did not know what to do next and took refuge more and more in his sketchbook. Whether he was in the streets of Newhaven or out in the country he was always churning out pen and ink drawings at great speed. The account in *Chambers's Edinburgh Journal*, the source followed by most writers, suggests this phase lasted for a long time. Besides crediting Howe with 'a number of large compositions' (the Cattle Fairs), it said he made 'many hundred sketches of a unique character', but that 'he grew more and more careless as to the proper completion of his pieces'. The depth of any depression he may have suffered should not be exaggerated, however, because many of the drawings are living evidence that his sense of humour was as keen as ever. Besides, as we have seen in chapter 7, he was involved in publications in 1829 and 1830, and afterwards, needing to have fifty portraits of animals ready to be engraved for *Portraits of Horses and Prize Cattle* in 1832, he was not short of challenges to his skill.

That he produced large numbers of these quick sketches is true. It was recorded in 1956 that a private owner in East Lothian had three hundred of them. This must almost certainly have been Mr J Kent Richardson, an artist who lived at Gullane and who presented forty-two of Howe's drawings to Perth Museum and Art Gallery in 1957, forty-two to Aberdeen Art Gallery in 1958, forty-three to Dundee Museum and Art Gallery and twenty to Kelvingrove Museum and Art Gallery in 1963, and also three to Edinburgh City Art Gallery. Other significant holdings of his drawings are in the National Gallery of Scotland which acquired ten through the Watson Bequest on the centenary of Howe's birth and has purchased eight since, Edinburgh City Library which has twelve, and the Royal Museum of Scotland five.

These quick drawings are unique in style, much simpler and cruder than his professional work for publication, but immediately recognisable as his, even when he forgot to sign his name. They are also unique in subject matter, since they are nearly all drawings of people with animals. Some subjects are dealt with more than once: *Drovers with cattle* and *The auld farmer and his mare*

twice each in the National Gallery, the *Drovers* again in Perth and Dundee and *The auld farmer and his mare* in four other versions elsewhere; *The carter's dinner*, once in Edinburgh and once in Glasgow; *Wandering Willie* also in both cities; *A farmer on horseback* passing one beggar in Edinburgh but two beggars in Glasgow. In another collection, a man with two monkeys is seen begging with no success, while in another sketch when an ample figure in a large cloak carrying a decorated cane, looking like Mr Bumble in *Oliver Twist*, passes by without giving anything to three maimed beggars—one with a stump of a leg, one blind in one eye—the looks of desperation and hatred on their faces are more bitter than in any other drawing by Howe. He drew *A fishwife with a creel getting a lift on a cart*, a common sight in Newhaven, no less than six times. Every one is different: in the Dundee drawing the carter is eying the girl carefully, in the Perth one they are cheerfully chattering, and in the Aberdeen one she has a ramshorn in her hand and is pouring him a drink. Only once, in the drawing in North Berwick Museum, did he ever finish the

Fishwife pours a drink for the carter. *Reproduced by courtesy of Aberdeen Art Gallery and Museums.*

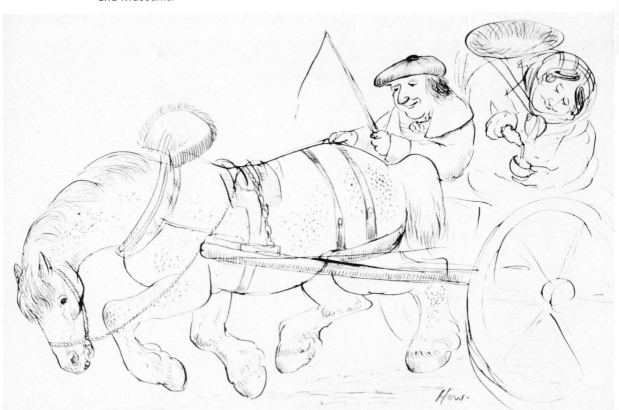

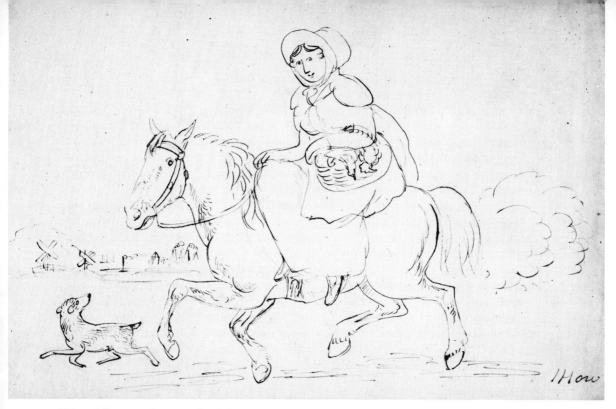

Sidesaddle to market, two fowls in basket. *Reproduced by courtesy of Royal Museum of Scotland.*

cart in enough detail to show what they had to sit on.

The drawings always show women riding sidesaddle. In one a girl with a check shawl and a ribbon in her hat looks completely unconcerned as her pony and her dog race along to market, the live duck and cockerel in the basket over her arm looking ahead like early aviators in the cockpit. Another drawing in another collection shows the same girl riding back home and now the faithful dog, charging along behind, is the one carrying the empty basket. The custom of farmers' wives sitting sideways behind their husbands on a workhorse is also recorded several times by Howe, in paintings as well as drawings, with never a hint of what prevented them falling off.

Tethering workhorses to graze was a common practice apparently, judging from the drawings of farm people riding on their backs and carrying a long rope with a stake on the end. One of the drawings found in Edinburgh City Library shows a groom riding a pony and leading a big dappled Clydesdale past a milestone twenty-five miles from Edinburgh. The horse, with a smart check blanket with an 'H' on it over its back to keep it warm, is a travelling stallion once a common sight round the farms. The 'H' could be the artist's initial but, since the name 'Howe' also appears on the milestone, this is not

so likely. As the Skirling to Edinburgh road is the one Howe knew best and Skirling is not much more than twenty-five miles from Edinburgh, the 'H' may indicate that the stallion was the property of the Hyndford estate which owned much of the land about there. In another drawing, seen as a photograph in the National Gallery of Scotland, the same stallion is portrayed stamping the ground as soon as it arrives at a farm.

The drawings in Perth Art Gallery are interesting for the series on racehorses and for the variety of domestic animals represented. On four out of the six drawings of racehorses Howe printed the words 'PERTH' or 'PERTH RACES', and although he dated only one after his signature it is enough to establish that his visit to Perth Races occurred in 1829. He employed considerable underdrawing in pencil in one drawing to try to record the exact posture of a horse under stress as it takes a bend at speed. In another, by

Top-hatted horseman with powerful Clydesdale. *Reproduced by courtesy of Aberdeen Art Gallery and Museums.*

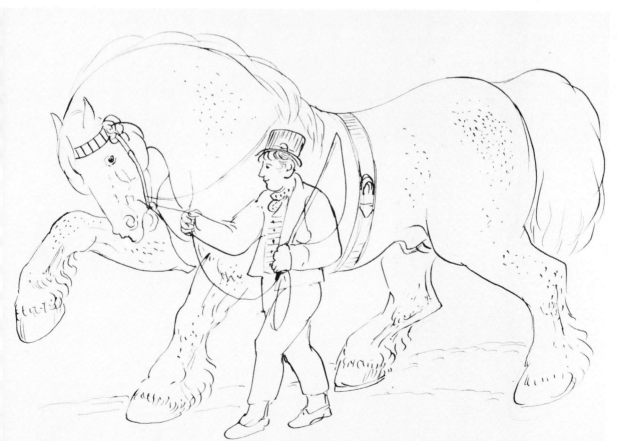

elongating the necks of the horses, he conveys how much they are straining to win. Outstanding among several drawings of sheep is one in pen and ink of a shepherd with two dogs driving a flock of sheep, their rumps tinted with red chalk; and in two scenes depicting tinkers beside their tripod fire, donkeys also appear with their baskets still strapped on.

Over thirty of the drawings in Aberdeen Art Gallery are exactly the same size and were probably drawn on the same pad at about the same time. The number of young animals among them, lambs with the sheep, a very thin foal beside its Clydesdale mother, cows with calves and a woman feeding calves, all point to Howe staying on a farm in spring and early summer, probably at Skirling. Alone among the galleries, Aberdeen has a few of the drawings by Howe from which engravings were made for publication. One, a detailed study in pencil of five sheep, became the engraving of sheep in Part 3 of *Breeds of Domestic Animals*; and another, the Aberdeenshire Horned Ox in pen and ink with heavy shading, appeared in Part 2 of *Portraits of Prize Cattle* in 1832.

The Dundee collection is rich in illustrations of the different kinds of work done by farmhorses in the fields—working as a pair in ploughing and harrowing, and singly in pulling rollers and bringing in the hay. One very

[*facing page*] Studies of racehorses. *Reproduced by courtesy of Dundee Art Galleries and Museums.*

Jockeys and horses at Perth Races. *Reproduced by courtesy of Perth Museum and Art Gallery.*

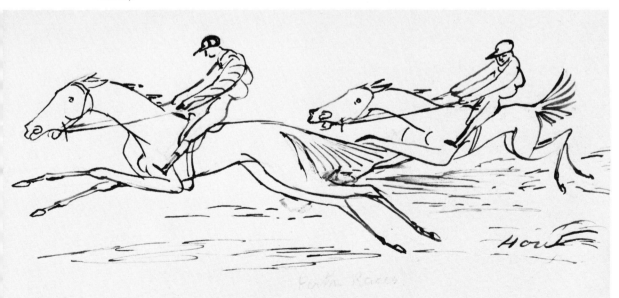

pleasing picture shows a ploughman riding one of his horses and leading the other as they turn their backs on the plough for the day. A pencil drawing of a workhorse in the stable which Howe must have admired is dubbed by the artist 'Scotch Every Inch of Him'.

Some of his drawings, done with a minimum of lines in pen and ink, are in the nature of cartoons, comic drawings to which he occasionally added a caption. A farmer beaming all over his broad face as he gallops along, for example, is subtitled 'Back from the fair weel contented'; and another wearing a huge bonnet and standing beside a cow is asked 'Sanders what price are ye speerin for that cow?' Such drawings, however, are more often cartoons without words, recording any incident Howe thought was funny—a sprightly steed startled by the braying of a donkey or the shocked look of a pony when a goat reaches up to steal hay almost out of its mouth. There are times when Howe appears to endow animals with human feelings and responses.

Other drawings provide illustrations of the use and usage of horses in transport in both town and country—coal carts of the Newcastle Coal Com-

Herd and dogs driving sheep: black ink and red chalk, 1829. *Reproduced by courtesy of Perth Museum and Art Gallery.*

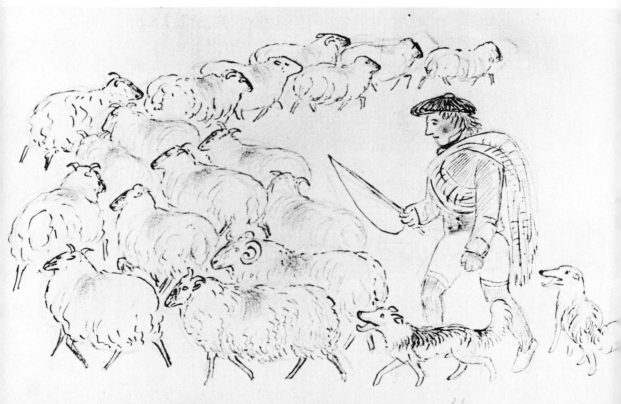

pany in Edinburgh, for example, pulled by three trace horses; the Royal Mail Coach to London; private carriages; a carter with a load of grain in boll-bags (weighing 140 lb. which it took a mighty man to handle) heading for the port of Leith; horses in timber yards; horses taking farmers to market; horses carrying loads in saddlebags and panniers; horses pulling carts of hay. Others show horses at the smiddy, also at the toll-bar in two pictures in the vicinity of Edinburgh. Donkeys feature too for riding, by a man and a boy on the same donkey in one case, and also for carrying things, usually in baskets but once, with sheepskins slung over their sides to protect them, carrying loads of heather besoms. A few depict other occupations, such as the drovers, shepherds, blacksmiths and the village tailor. There is no doubt that his drawings are a rich source of information for the historian of farming, transport and costume.

Only a few drawings are of sporting scenes: only one depicts huntsmen and hounds with a fox. In one in Perth Art Gallery, two dead hares are hanging

Plough team head for home. *Reproduced by courtesy of Dundee Art Galleries and Museums.*

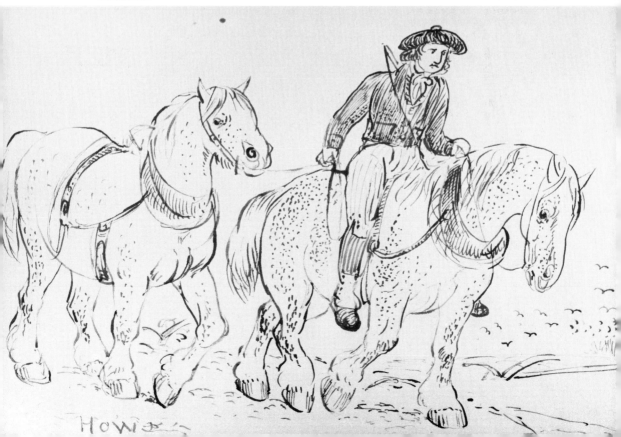

over the side of a pony close to the proud greyhounds which caught them. In a third in Dundee Art Gallery, a huge Highlander with a gun has the carcase of a stag slung over his shoulder. Days at the races, on the other hand, feature in a good number of Howe's drawings. In two other studies, called *Highlanders on the Move*, women and children, including babies, are seen travelling on carts with all their belongings, with kilted soldiers walking beside them down the slope from a castle. The site suggests that they are soldiers' families on their way to a new depot.

Lady Stair's House in Edinburgh's Royal Mile has three drawings of scenes from Robert Burns' poems—a realistic sketch of *The Jolly Beggars* including the one-legged 'son of Mars', Tam o' Shanter leaving the inn at last under the title *Drunk and Glorious*, and a touching drawing of the auld farmer greeting his auld mare at New Year in the stable and giving her some unthreshed corn with the words:

> A guid New Year I wish thee, Maggie
> Hae, there's a ripp to thy auld baggie [belly]

Aged farmer's salutation to his mare, Maggie. *Reproduced by courtesy of National Galleries of Scotland, Edinburgh.*

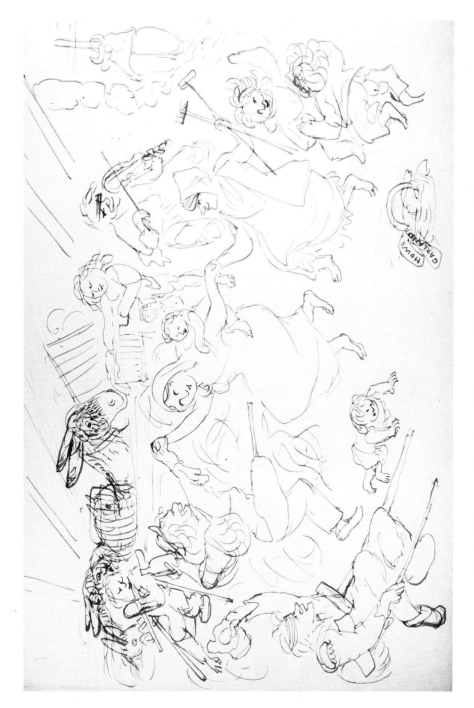

The Jolly Beggars. *Reproduced by courtesy of Dundee Art Gallery and Museums.*

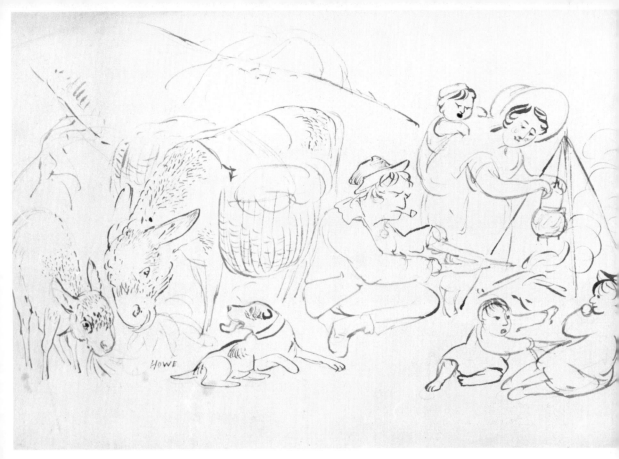

Gypsy encampment with donkeys. *Reproduced by courtesy of Perth Museum and Art Gallery.*

A similar scene but out in the open air occurs in a drawing in the National Gallery of Scotland, and in another, Tam o' Shanter is looking remarkably unworried as he approaches 'Alloway's auld haunted kirk'. Aberdeen and Dundee Art Galleries hold other versions of both, and Dundee also has two sketches of *The Jolly Beggars*. Although the number of scenes he drew from Burns' poems is fairly small, their existence indicates how much these characters had become established in popular culture in the time of Howe, who was probably no great reader.

Very few of the drawings which have come to light so far are dated. The only dates found, 1829, 1830 and 1831, encourage the view that most of them belong to this fairly short period but, considering their large number and his ruling passion for drawing, they may almost as easily have occupied most of his later years.

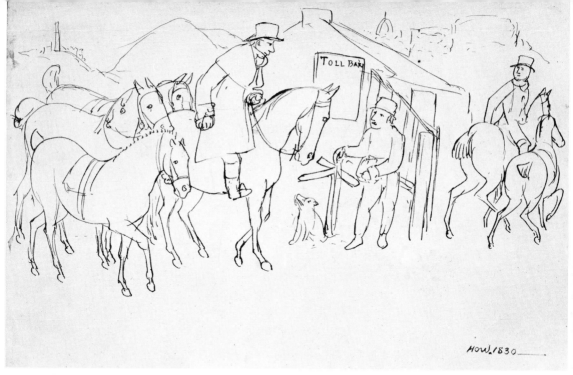

The Toll Bar. *Reproduced by courtesy of National Galleries of Scotland, Edinburgh.*

Fine pencil drawing of a horse and rider. *Reproduced by courtesy of Royal Highland and Agricultural Society of Scotland.*

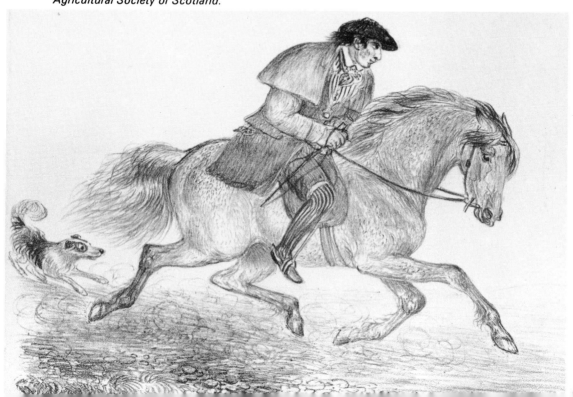

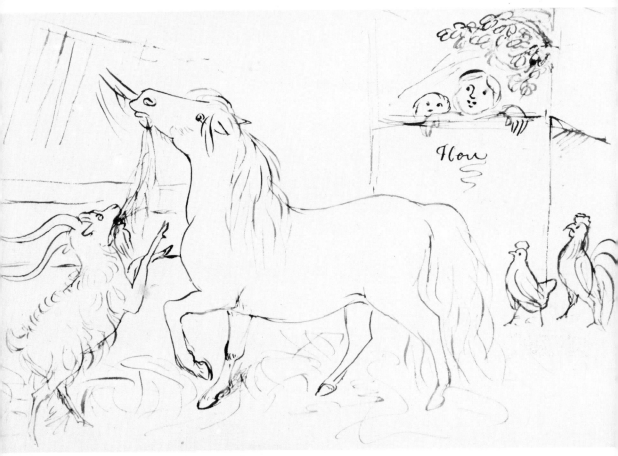

Goat stealing from pony. *Reproduced by courtesy of Aberdeen Art Gallery and Museums.*

The Later Years

Howe's drawings represent a considerable achievement and, taken together with the paintings of fairs, they give the lie to the view that after he moved to Newhaven in 1821 his creative moments were so few that his career slid unrelentingly downhill. True, he seldom exhibited. A single painting, typically entitled *Horse and Cart*, appeared in the Royal Institution exhibition in 1829 and the painting with the latest known date by Howe is *Goliath winning at Musselburgh Races* in 1835.

Whether he submitted paintings to the RSA in the 1830's which were repeatedly rejected, there is no way of knowing. It is known, however, that in 1834 he returned to Edinburgh to live with the Robertsons, the family of a pupil of his, and that in 1836 he had one picture exhibited in the RSA. In the catalogue it was called *A Gentleman on his Fast Trotter*. In fact he submitted

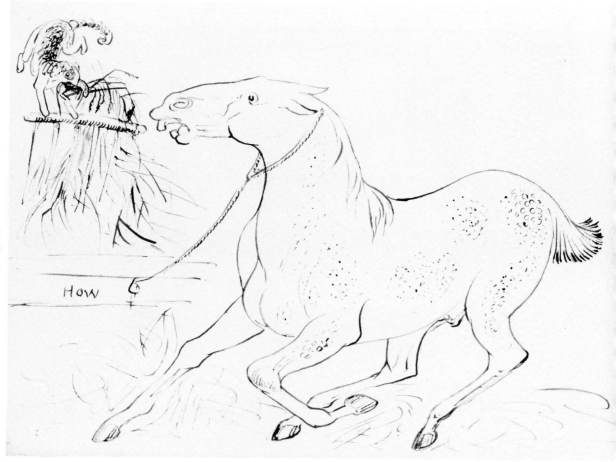

Pony startled by cat. *Reproduced by courtesy of Aberdeen Art Gallery and Museums.*

two pictures, one of which was a delicate pencil sketch of a lady sitting sidesaddle on a fine horse, which was perhaps too similar to an engraving in *The Life of the Horse* in 1824 and was not accepted. The other is a pen and ink drawing of a man sitting in the lightest of two-wheeled carriages with a look of terror on his face as he tries to control a horse going full pelt. It is an impressive drawing of a horse at speed, done in his familiar economical style. While the exhibition was on, James Howe was ill and, in the hope that the country air would restore his health, he moved out to Townhead farm (now Galalaw) at Skirling, which his uncle, William Wilson farmed. He was there at the time of the June Horse Fair and among people he knew for about three months. Constant coughing, however, made him weak and he died of a burst blood vessel on 11 July 1836.

No one ever went to collect his pictures from the RSA, where they have been ever since.

He was buried in Skirling churchyard quite close to the house where he was born. On the tombstone which his relatives and admirers erected to his memory, his palette and brushes are carved above the lines which James Proudfoot, the minister of Coulter composed:

> He who could make with life the canvas glow,
> In death's dark slumber lies this turf below;
> But death which triumphs o'er the mouldering frame,
> Dims not the lustre of the painter's name.

The hundred and fifty years which have passed since then have no doubt blurred many things about him which once were common knowledge but in the village people talk about him still. In Skirling also his name is perpetuated in *Howe's Brae*, the address of the new houses standing on the old Cattle Market which he painted long ago. Thankfully the pictures he created are with us still.

[*facing page*] Memorial to James Howe in Skirling churchyard – below the palette and brushes are the words:

Here Rest the Remains of James Howe, artist; Son of Revd William Howe Minister of Skirling; Born 30th August 1780 Died 11th July 1836. He who could make with life the canvas glow, In death's dark slumber lies this turf below; But death which triumphs o'er the mouldering frame, Dims not the lustre of the painter's name.
Erected by his admirers in his native parish

[*overleaf top*] Galalaw Farm (formerly called Townhead) where James Howe died.

[*bottom*] Street name in Skirling.

FRIEND OF ALL HORSES

Skirling had no doubts about Howe's greatness. Writing for the *New Statistical Account*[33] in 1834, the minister John Alpine immediately selected James Howe as the parish's most distinguished son. His reasons were the popular appeal of the panoramas and Howe's unrivalled stature as an animal painter, which contemporary artists appear to have acknowledged. Brydall goes so far as to maintain that some of the most celebrated among them 'gladly availed

Trace horses on the turn. *Reproduced by courtesy of Royal Museum of Scotland.*

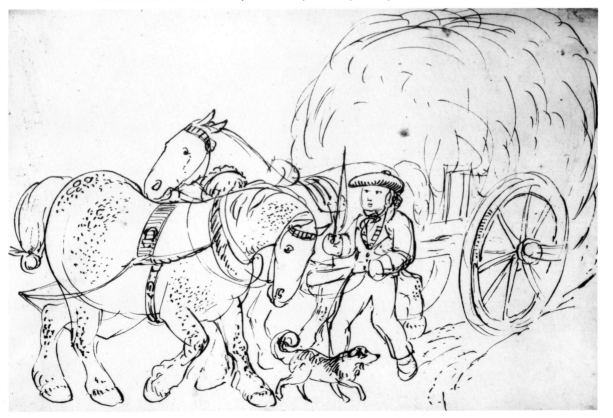

themselves of the aid of his brush in putting cattle into their pictures' but he does not reveal who these artists were.[34]

Caw last century and Cursiter in this among the national critics both appreciated him. Although he saw only one of the paintings of Skirling fair, Caw enjoyed it because it was full of fun and teeming with incident and he praised the workmanship, even if it was unpolished, because it was 'assured and bold'. Cursiter in placing Howe in the category of 'minor painters with little skill but something to say'[35] is first recalling the fact that Howe had with no formal art training simply become an artist, and then he predicts perceptively that the day might come when people might prefer the honest representation Howe offers, for example in the pen and ink drawings he did so quickly, to displays of formal skill by so many others. Perhaps that day has come.

As an artist Howe appears to have had two styles. The earlier, and the one clients expected in a portrait painter, was careful and professionally competent, bringing out the character and distinguishing features of the people

Bull in harness, owned by Monteith of Closeburn, used to pull a four-wheeled coal waggon on a railway. From *Portraits of Horses and Prize Cattle.*

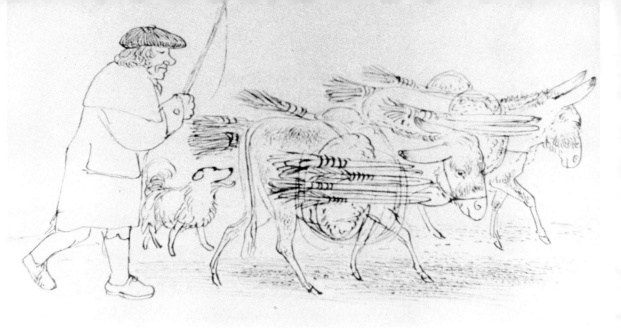

Donkeys laden with besoms, popular for sweeping out houses and barns.

A horse carrying fish in panniers, twice as much as a man could carry. *Reproduced by courtesy of Dundee Art Galleries and Museum.*

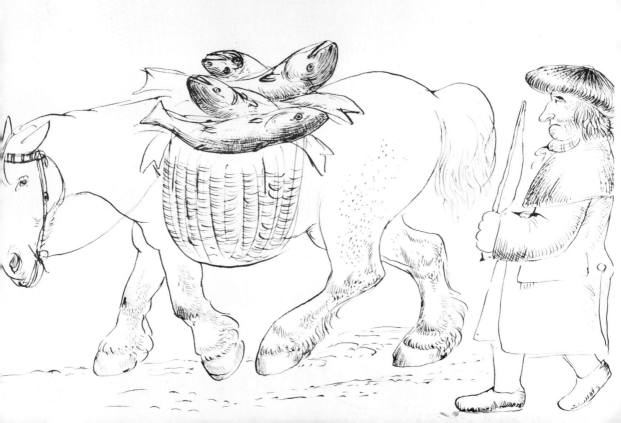

and the animals he painted. It is to be seen in early paintings like *Hawking at Barochan* and reaches its peak perhaps in *Preparing to Start* in 1821 which, although the subject is given as the start of a race at Musselburgh, is in fact a portrait of the ultimate winner, Outcry, painted for its owner, with the other horses occupying subordinate positions. The same style runs through all his drawings of animals from 1811 to the works published as engravings between 1824 and 1832 which are now of interest to students of agricultural history.

His second style, which is to be seen in the lively way he painted the country fairs and in the *Drawings for Fun* in chapter 8, may mark a return to his natural way of drawing and painting. Done with great economy of line and capacity to occupy the available space, the pen and ink drawings which Cursiter admired may not be great art but, because they record incidents in everyday life, they are liable to be appreciated for other reasons by people interested in social history. Probably the circumstance which prompted him to change his style was the huge financial success his panoramas achieved and he had painted them at speed.

With a change in style went a change in content. As an artist who had previously made his living painting thoroughbreds by commission, Howe broke new ground when he began to paint workhorses and so many big pictures of all kinds of farm animals for sale at country fairs.

Like Walter Geikie, he found subjects in the commonplace scenes around him but, compared with Geikie, Howe was less skilled in handling groups of people and he belonged to no school. He was something of an eccentric who had deviated from the usual course artists followed in his day. A simple man, he took an almost childlike delight in anything comical and ridiculous and this comes through in many of his casual drawings and in incidents in his paintings of fairs. One essential quality which pervades his work is the unique understanding he had with horses, finding joy in the graceful curve trace horses make when turning, or in the moment when ponies are vying with each other to catch his eye.

REFERENCES

1 W Hunter *Biggar and the House of Fleming* (Edinburgh 1867) p348
2 JR Brotchie 'James Howe' in *Scottish Art Review* vol 4 no 1 (1952) pp24–5; W Anderson *The Scottish Nation* (Edinburgh 1869) vol 2 p499
3 J W Buchan *History of Peeblesshire* (Glasgow 1925–7) vol 3 p210
4 J L Caw *Scottish Painting Past and Present* (Edinburgh 1908) p196
5 *Register of Edinburgh Apprentices* 1756–1800 (Scottish Record Society 1963) p31
6 *Book of the Old Edinburgh Club* (1935) vol xx p21
7 D & F Irwin *Scottish Painters at Home and Abroad* 1700–1900 (London 1975) p126
8 *Register of Edinburgh Apprentices* pp44,47
9 *Caledonian Mercury* 25 July 1836
10 Lord Cockburn *Memorials of His Time* (Edinburgh 1945 edn) p229
11 *Roll of Edinburgh Burgesses* 1761–1841 (Scottish Record Society 1933) p106
12 R Brydall *Art in Scotland* (Edinburgh 1889) p426
13 Catalogue of the Earl of Buchan's sale Edinburgh 1859 (National Library of Scotland)
14 W T Whitley *Art in England* 1800–1820 (Cambridge 1928) p135; D & F Irwin p192
15 Whitley p134
16 J Cleghorn 'Agriculture' in *Encyclopaedia Britannica* Supplement to the 4th and 5th edns (A Constable Edinburgh 1815) vol 1 pt 1 plates X,XI,XII
17 Information from Brian Lambie, Biggar Museum Trust
18 Called 'Chasse au faucon' in E Bénézit *Dictionnaire des Peintres* (Paris 1976) vol 5 p21
19 Catalogues in the library of the Royal Scottish Academy
20 B Patterson *Border Magazine* 1936 p166; B C Skinner *Scottish Studies* vol 10 pt 1 1966 p112
21 *Edinburgh Evening Courant* 13 July 1815
22 First in *Chambers's Edinburgh Journal* 1839 p324
23 Gray's *Edinburgh and Leith Directory* 1836–7 p87
24 The oldest surviving panorama in Europe appears to be a coastal scene by Mestag in 1881 in the Netherlands: information from Elspeth King, The People's Palace, Glasgow

25 Copy of a letter from Lord Panmure to Montrose Natural History and Antiquarian Society 4 October 1842: information from Norman K Atkinson, Montrose Museum
26 *Chambers's Edinburgh Journal* 1839 p324
27 Catalogue in the library of the Royal Scottish Academy
28 D Young *Edinburgh in the Age of Sir Walter Scott* (Norman Oklahoma 1965) p97
29 Information from Brian Lambie, Biggar Museum Trust
30 David Cleghorn–Thomson 'A Neglected Animal Painter' *The Scotsman* 27 Oct 1956
31 *Chambers's Edinburgh Journal* 1839 p324
32 Copy in the Scottish National Portrait Gallery
33 *New Statistical Account* Peeblesshire 1845 vol 3 p102
34 Brydall p426
35 S Cursiter *Scottish Art* (London 1949) p77

INDEX